The Practice *of*
Contemplative
Photography

The Practice of Contemplative Photography

SEEING THE WORLD WITH FRESH EYES

Andy Karr & Michael Wood

SHAMBHALA
Boston & London
2011

Shambhala Publications, Inc.
Horticultural Hall
300 Massachusetts Avenue
Boston, Massachusetts 02115
www.shambhala.com

13 12 11 10 9 8 7 6 5

Printed in China

♾This edition is printed on acid-free paper that meets the American National Standards Institute z39.48 Standard.
♻Shambhala Publications makes every effort to print on recycled paper.
For more information please visit www.shambhala.com.
Distributed in the United States by Penguin Random House LLC and in Canada by Random House of Canada Ltd

Designed by James D. Skatges

Library of Congress Cataloging-in-Publication Data
Karr, Andy.
The practice of contemplative photography: seeing the world with fresh eyes / Andy Karr & Michael Wood.—1st ed.
p. cm.
Includes bibliographical references.
ISBN 978-1-59030-779-3 (pbk.: alk. paper)
1. Composition (Photography) 2. Photography—Technique. 3. Photography, Artistic.
I. Wood, Michael, 1949 Feb. 19– II. Title.
TR179.K37 2010
770.1—dc22
2010031808

The inexpressible is the only thing that is worthwhile expressing.
—Frederick Franck, *The Zen of Seeing*

Contents

Preface

Photography is the simplest art form. Taking a photograph does not require strong hands, fine motor control, or years of training. To make a picture, all you need to do is point the camera and press a button. (Sometimes you might also need to adjust a few settings.) For the first century of photography's existence, the arbiters of the art world did not accept that it was an artistic medium at all because the techniques for producing images were so mechanical.

But photography is not purely a mechanical process. You need to know how to look, where to point the camera, and when to press the button. These acts depend on the eye, mind, and heart. All the photographic greats used similar skills and equipment to produce dramatically different bodies of artistic work. This indicates how important eye, mind, and heart are in photography.

A great deal is written about the technical aspects of photography. There are lots of books and articles about different types of equipment, what settings to use in various photographic situations, recipes for composing interesting photos, and of course, "tips and tricks" for achieving dramatic effects.

On the other hand, little is written about how to work with eye, mind, and heart to produce fine works of art or how photography can be used to expand your vision and your appreciation of the world. Henri Cartier-Bresson expressed this well when he wrote, "Technique is important only insofar as you must master it in order to communicate what you see. . . . In any case, people think far too much about techniques and not enough about seeing."[1]

It is fairly easy to master the basic technical skills of photography. In fact, the sophistication of modern digital cameras makes many of these skills superfluous. It is much

harder to develop your ability to see and learn to work with the subtle dynamics of your own mind, yet this is where the potential for real artistry and joy is to be found. For us, this is the really interesting challenge.

The Practice of Contemplative Photography is a book about the art of photography that emphasizes developing the ability to see. It offers instructions, exercises, and photographic assignments that form a thorough introduction to the practice of contemplative photography, a practice that has been elaborated and refined over twenty-five years. This practice offers you a new way of taking photographs and a new way of seeing.

The Practice *of*
Contemplative
Photography

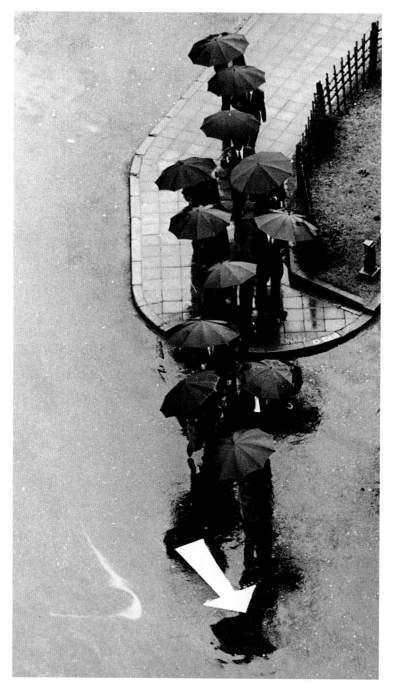

André Kertész, "Rainy Day, Tokyo," 1968.

1

PHOTOGRAPHY AND SEEING

Today, it is raining.

On a day like this you might see red, yellow, or green traffic lights reflected on wet pavement. You might see raindrops running down a windowpane or hanging from a railing or overhead wire. You might see two people walking under a bright green umbrella. You might see a dull gray sky or a wet red truck. Inside, there will be soft shadows and muted colors. You might even look through the drops on a window and see the landscape distorted by odd-shaped raindrop lenses.

When the sun comes out, you might see patterns of light coming through venetian blinds. You might see the complex shadows of trees or bright green leaves against darker foliage. You might see the shapes of someone's eyes in profile, or the texture of the fabric of the clothing on your leg. You might look up at a bright sky with high, wispy clouds or notice clumps of light reflected by the windows of an office building onto light gray streets. You might observe a dog sitting on the carpet, half in bright sunlight and half in deep shadow.

At dusk the light changes again, and you might see white buildings become orange or pink. As it gets dark, the same buildings might become gray. The sky, too, will change its appearance. If you awake in the middle of the night, the walls and furniture will be monochromatic, illuminated by the moon or a streetlight.

The possibilities of perception are limitless, and clear seeing is joyful.

Creativity is also limitless. Creativity often seems like an unusual gift that few people are born with or somehow manage to acquire, but creativity is accessible to everyone. It naturally arises from your basic nature when you are open to it. Creativity is something

to be uncovered, not something to be wished for. It is not a scarce resource that runs out if you draw on it. Creative possibilities are endless. You don't need to take this on faith: you can experience it for yourself.

Unfortunately, much of the time, we are cut off from clear seeing and the creative potential of our basic being. Instead, we get caught up in cascades of internal dialogue and emotionality. Immersed in thoughts, daydreams, and projections, we fabricate our personal versions of the world and dwell within them like silkworms in cocoons. Instead of appreciating the raindrops on the window, we experience something like, "This weather is nasty. I have to get to work, and I need a new raincoat. I hope it clears up for the weekend." Seeing patterns of light on the counter becomes, "I wish we could afford some nice fabric shades instead of these cheap metal miniblinds. I wonder what color would look nice in here."

Generally we are unaware of these currents of mental activity, and it is hard to distinguish what we see from what we think about. For example, when we are in a restaurant or on a bus with a bunch of strangers, we might look around and think, "He looks unpleasant; that person over there looks nice; she looks disagreeable." We imagine that we see these people the way they really are, that we are seeing their real characteristics, but *unpleasant, nice,* and *disagreeable* are not things that can be seen like green blouses or gray hats. They are the projections of our thoughts. Thinking mind is working all the time, projecting, labeling, categorizing. These thoughts seem so believable, but if we recollect how often our first impressions of people turn out to be wrong, we will see how random this thinking process really is.

Photography can be used to help distinguish the *seen* from the *imagined,* since the camera registers only what is seen. It does not record mental fabrications. As the photographer Aaron Siskind said, "We look at the world and see what we have learned to believe is there, [what] we have been conditioned to expect. . . . But, as photographers, we must learn to relax our beliefs."[1]

We are often surprised to find that our photographs do not show what we thought we were shooting. John Szarkowski, photographer, historian, and astute critic, was the director of the Department of Photography of the Museum of Modern Art in New York from 1962 to 1991. He wrote this humorous account of the camera's lack of imagination:

> No mechanism has ever been devised that has recorded visual fact so clearly as photography. The consistent flaw in the system has been that it has recorded the wrong facts: not what we knew was there but what has appeared to be there.[2]

Contemplative Photography

The word *contemplate* sometimes means to think things over, but when we use the term, we are indicating a process of reflection that draws on a deeper level of intelligence than our usual way of thinking about things. The root meaning of the word *contemplate* is connected with careful observation. It means to be present with something in an open space. This space is created by letting go of the currents of mental activity that obscure our natural insight and awareness.

In contemplative photography the camera's literalness is used as a mirror to reflect your state of mind. It shows when you shot what you *saw*—what actually appeared—and when you shot what you *imagined*. When a properly exposed photograph faithfully replicates your original perception, you saw clearly. When your original perception is masked in the photograph by shadows, reflections, or other extraneous things that you didn't notice, you were imagining. You can distinguish which it was by the results. Clear seeing produces clear, fresh images. Photographs that aren't grounded in clear seeing are usually disappointing. (You might get lucky and get a good shot of something you didn't see clearly, but that is the exception.)

How does clear seeing produce clear images? When you see clearly, your vision is not obscured by expectations about getting a good or bad shot, agitation about the best technique for making the picture, thoughts about how beautiful or ugly the subject is, or worries about expressing yourself and becoming famous. Instead, clear seeing and the creativity of your basic being connect directly, and you produce images that are the equivalents (this is Alfred Stieglitz's term) of what you saw. What resonated within you in the original seeing will also resonate in the photograph.

The Conventional Approach

Naturally, there are a variety of approaches to photography. Looking at the differences between various approaches will help clarify what we mean by contemplative photography and show where it fits within the photographic tradition.

The most conventional approach to photography is to emphasize *subject matter*, regarding that as the key to successful photographs. This approach is all about finding the right landscapes, catching the right emotions, revealing the right sociological conditions. The conventional photographer is a bit like a big game hunter searching for prey or a butterfly collector looking for another specimen to add to his or her collection.

Growing up in a particular culture, we naturally form concepts about what subject

matter is attractive, what is artistic, what is worthwhile. These concepts are like filters, or templates that overlay our experience. The conventional photographer looks for subjects that fit these templates. Bound by these concepts of what is beautiful or dramatic or unusual, he or she searches for scenes that fit the concepts—a dramatic sunset, a beautiful waterfall—*snap!*

Because these concepts divert the photographer from the world of visual form, they become obstacles to clear seeing. Distracted by the concepts, vision becomes vague and distorted. With perception clouded by mental images, it is hard for conventional photographers to fully see what they are shooting and easy for them to overlook everything that doesn't fit the templates. In this way, their experience becomes barren, and their photographs often miss the mark.

Concepts about pictorial techniques can further constrict their vision. Trying to see the world through *the rule of thirds* to create good compositions, or shooting very early or very late in the day because the light will be warm, or playing with exposure and color balance to make images look more dramatic, turns photographers away from things as they are, and toward their thoughts about how they want them to appear. This separates them from the immediacy of their experience. As Edward Weston put it,

> When subject matter is forced to fit into preconceived patterns, there can be no freshness of vision. Following rules of composition can only lead to a tedious repetition of pictorial clichés.[3]

Photographic tricks can make matters worse by substituting gadgets and gimmicks for clear seeing. Using special filters or settings to make scenes look more colorful, or very slow shutter speeds to make moving objects look graceful and plastic, or multiple exposures to get rhythmically repeating images, or (our least favorite) tilting the camera at odd angles to get unusual framing—all of these techniques produce banal photographs. Photographer and writer Robert Adams wrote,

> Odd angles, extreme lenses, and eccentric darkroom techniques reveal a struggle to substitute shock and technology for sight. How many photographers of importance, after all, have relied on long telephoto lenses? Instead, their work is usually marked by an economy of means.[4]

Beyond the Conventional

There are several photographic approaches that don't rely on conventional templates and techniques. One of them emphasizes *imagination* and *contrivance*. Surrealists, fash-

ion photographers, and conceptual artists shoot in this way. When it is well executed, this approach can produce striking and memorable photographs, but the images tend to be stylized and separated from our experience, appealing more to the brain than to the heart. The staging and formality of these pictures tends to create an emotional distance from the viewer that discourages empathy. Man Ray, László Moholy-Nagy, Irving Penn, Richard Avedon, and Bernd and Hilla Becher are examples of people who excelled at this type of photography.

Another approach emphasizes *craft* or *technique*. Ansel Adams is probably the best-known photographer of this type. He had an extraordinary ability to express the tonal values of nature in prints of exceptional beauty. Technique and subject matter dominated his work. Andreas Gursky is a contemporary photographer whose enormous, detailed prints exemplify a similar esthetic. In this craft-oriented approach, what is most striking is not the freshness of seeing but the rich quality of the photographic expression. This approach can produce superb photographic objects, much the way other craftsmen create exquisite lacquer boxes or artfully blown vases.

For us, the most interesting approach to photography emphasizes the experience of *seeing*. It is what Henri Cartier-Bresson described as "putting one's head, one's eye and one's heart on the same axis."[5] From the contemplative perspective, we might describe this as connecting clear seeing with our inherent creativity. This seems to be the core approach of the great masters of photography: their work is thoroughly grounded in seeing. Craft has its place. Intention has its place. But the ground is definitely clear seeing.

Who are these masters? Our list would include Alfred Stieglitz, Edward Weston, Tina Modotti, André Kertész, Paul Strand, Henri Cartier-Bresson, and Robert Adams (you may well have your own list). The images of these photographers are not constrained by subject matter or pictorial technique. They are not contrived or fabricated. They do not resort to formulas or gimmicks. You can tell this from their photographs.

Most photographers prefer to let their images speak for them, but a few quotations might reinforce our message. Henri Cartier-Bresson offers key insights into this approach. He says that camera work should be nonconceptual, that good images resonate at the core of our being, and that the artificial and contrived are deadly. This is how he put it:

> Thinking should be done beforehand and afterwards—never while actually taking a photograph. Success depends on the extent of one's general culture, on one's set of values, one's clarity of mind and vivacity. The thing to be feared most is the artificially contrived, the contrary to life.[6]

Putting this conclusion positively, the *uncontrived* is what is true to life. This is not meant as an objective standard of truth, it is more like *being* true, being willing to express things just as they are, without dressing them up in any way. People often associate the creative process with dressing up reality to make it "Art." From our perspective, genuine art expresses things simply and elegantly as they are. In this way, it expresses what is normally impossible to express. Edward Weston described this in his *Daybooks:*

> "Art" is considered as a "self-expression." I am no longer trying to "express my-self," to impose my own personality on nature, but without prejudice, without falsification, to become identified with nature, to see or "know" things as they are, their very essence, so that what I record is not an interpretation—my idea of what nature should be—but a revelation, a piercing of the smoke screen artifi-cially cast over life by neurosis, into an absolute, impersonal recognition.[7]

This approach goes beyond photography and applies to all of the arts. Paul Strand expressed this nicely when he said that the unfabricated truth is the basis for genuine artistic endeavor and what gives life to art:

> The material of the artist lies not within himself nor in the fabrications of his imagination, but in the world around him. . . . The artist's world is limitless. It can be found anywhere far from where he lives or a few feet away. It is always on his doorstep.[8]

The practice of contemplative photography fits solidly within this artistic tradition.

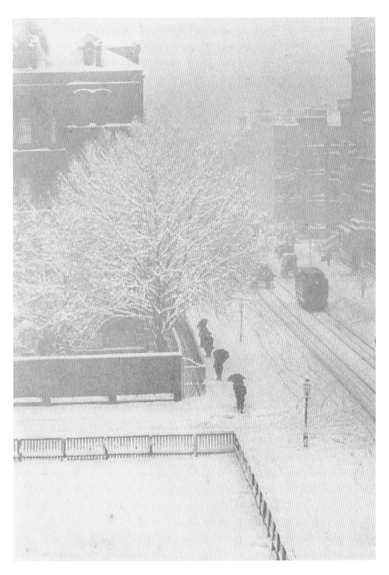

Alfred Stieglitz, "Snapshot, from My Window," New York, 1907.

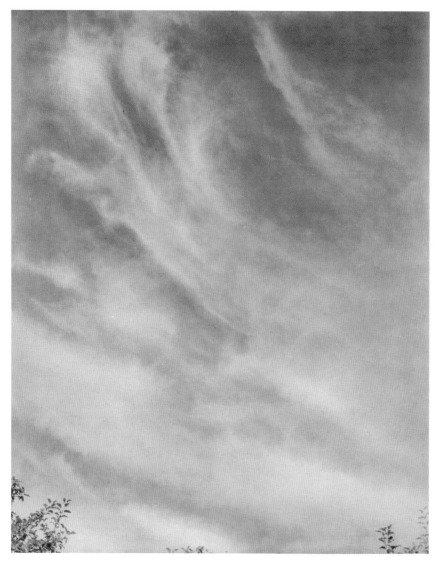

Alfred Stieglitz, "Equivalent," 1930.

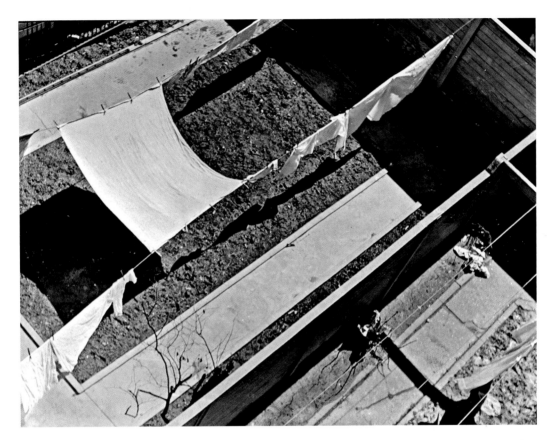

Paul Strand, "Geometric Backyards," New York, 1917.

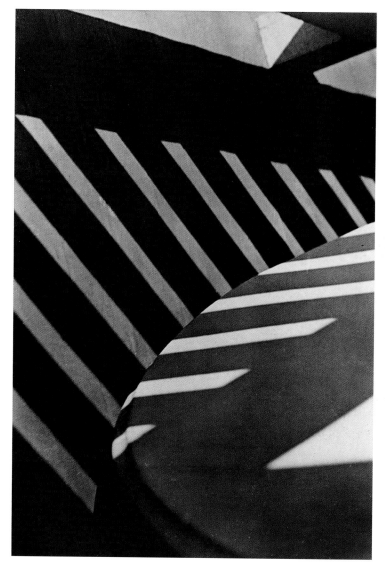

Paul Strand, "Abstraction, Porch Shadows," Connecticut, 1916.

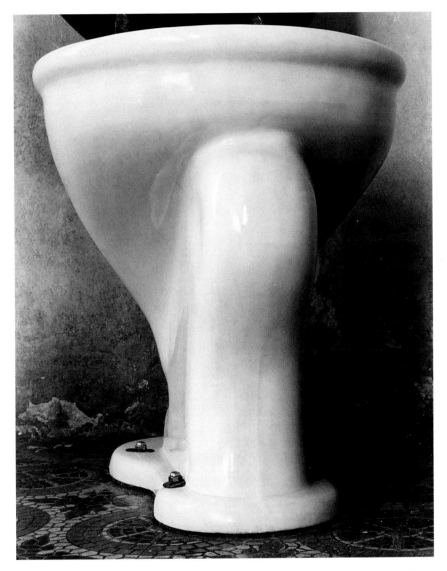

Edward Weston, "Excusado," Mexico, 1925.

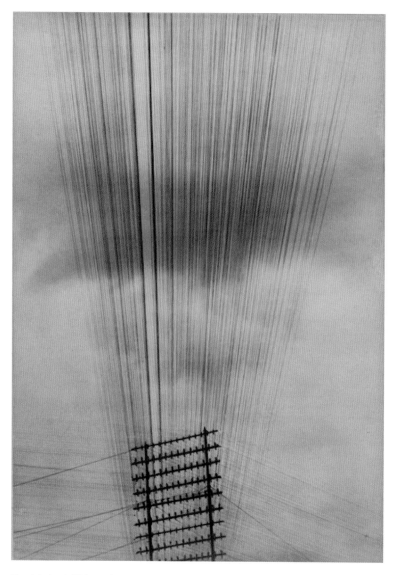

Tina Modotti, "Telegraph Wires," Mexico, 1925.

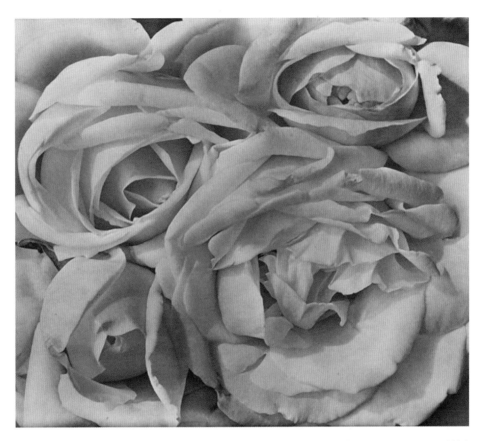

Tina Modotti, "Roses," Mexico, 1924.

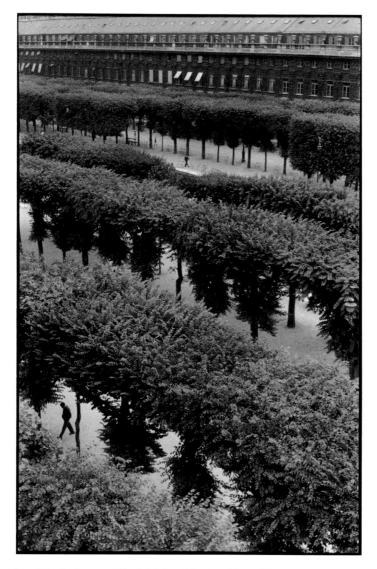

Henri Cartier-Bresson, "The Palais Royal Gardens," Paris, 1959.

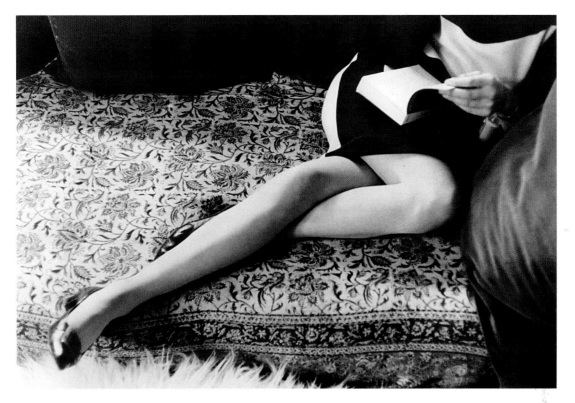

Henri Cartier-Bresson, "Martine's Legs," 1967.

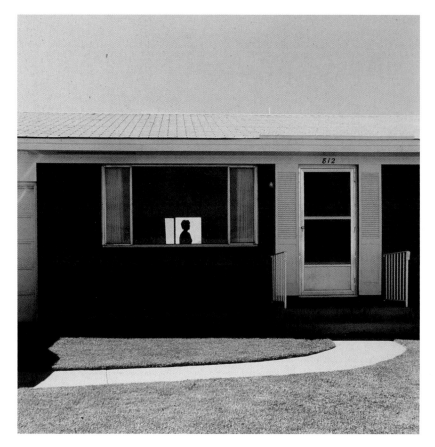

Robert Adams, "Colorado Springs, Colorado, 1968."

Robert Adams, "Untitled (from Questions for an Overcast Day), 2005."

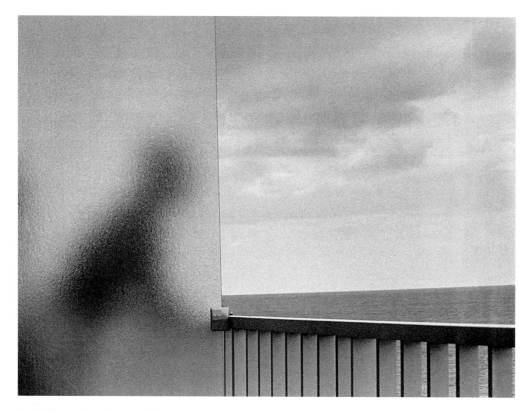

André Kertész, "Martinique," 1971.

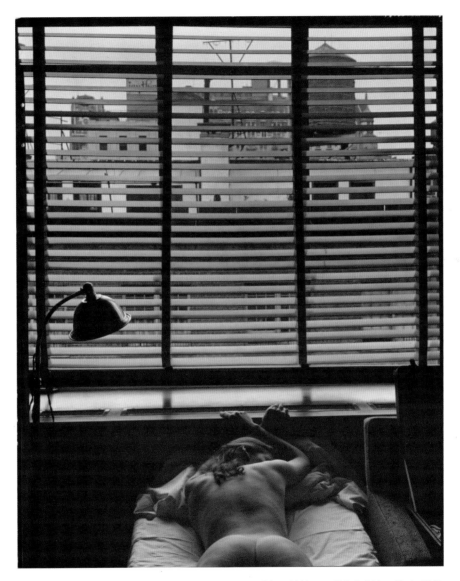

Edward Weston, "Nude," New York, 1941.

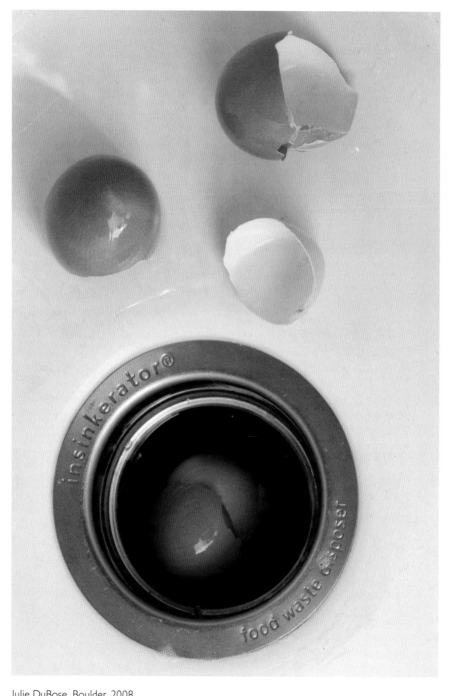

Julie DuBose, Boulder, 2008.

2

ART IN EVERYDAY LIFE

This ordinary, workaday world is rich and good.

It might not seem that way at six in the morning when you are rushing to prepare your coffee or tea and get out the door to go to work, or when you are tired and irritated after dinner and have to take out the garbage. Instead, ordinary life might seem hassled, repetitive, and boring. When you are impatient, resentful, or uninterested in daily life, you will be blind to the potential for living cheerfully and creatively.

Life seems repetitive and boring when you don't notice the uniqueness of each moment and the constant, subtle changes that are going on all around you. For example, you might have the same thing for breakfast every morning and not notice that it tastes different each day because of natural fluctuations of your body and mind and small variations in the details of your meal.

Even though things usually seem solid and enduring, nothing really lasts a second moment. Our experiences are always in the process of disintegrating and transforming. As photographers, we can know this intimately. Photographers are always working with light, and light is always changing. The brightness changes; the angle changes; the color changes; the diffuseness changes. Not only does the light change, whatever is illuminated changes with the light. As Mies van der Rohe, one of the great pioneers of modern architecture and design, famously observed, "God is in the details."

Ordinary experience is the raw material of our photographic art. Photographer, writer, and curator Beaumont Newhall wrote, "We are not interested in the unusual, but in the usual seen unusually."[1] When we separate our artistic activity from daily life, we cut ourselves off from our most valuable resource. We divide the world into the worthwhile and the unimportant; the meaningful and the merely functional. Instead of appreciating

what we have, we look for something better, something more beautiful, more entertaining. Seeking extraordinary perceptions and special artistic experiences leads us to overlook the riches that surround us. We might dream of being successful artists, living in the south of France or northern California, while ignoring the golden glow of sunlight on the kitchen sink. Instead of looking elsewhere for nourishment, we can live artistic, elegant lives, appreciating the details of our ordinary existence.

We should be clear about what we mean by artistic living. It does *not* mean surrounding yourself with beautiful things and banishing everything that is ugly: choosing only to look at fresh flowers and rejecting dead leaves ignores the deep beauty that both share when you open your eyes to them. Labeling things "beautiful" and "ugly" masks what they *really* look like. When you pick and choose in this way, all you really see is the masks, which are your own mental fabrications. Living artistically means appreciating things just as they are, in an intimate, unbiased way.

Living artistically also doesn't mean cultivating an artistic persona. You don't need to create elaborate rituals so that preparing dinner and doing the dishes becomes "Art." Trying to live an exceptional, beautiful life will only alienate you from the ordinary. Instead, the way to live artistically is to conduct ordinary activity in a relaxed and attentive way.

Finally, artistic living is not something you can go out and buy, like an extreme makeover. It arises from within.

Living artistically means seeing and caring for the details of your world. You can always take a moment to uplift your situation, no matter how basic it is. Just wiping the bathroom counter after you brush your teeth will remove the stains of resentment and carelessness. What matters isn't how luxurious your surroundings are, but how much you can appreciate the richness and freshness of your experience.

Revealing Natural Artistry

Strangely enough, you don't need to learn how to be artistic. It is as natural as breathing and the beating of your heart. Nevertheless, natural artistry is often inaccessible because it is concealed by preoccupation or resentment. A good analogy for this is the way the sun constantly radiates light even though you can't always see it. The sun is *always* shining, even when clouds cover the sky. No one has to make the sun shine. Sunshine becomes visible when the wind removes the clouds. Like that, artistry arises from mind's natural wakefulness, creativity, and humor when the obstacles that obscure it are cleared away. This is the main point of the whole contemplative endeavor: you don't need to learn how to fabricate creativity; you need to learn to remove the clouds that prevent it from expressing itself.

Before you can learn to remove the clouds, you need to understand their nature. We have briefly mentioned the way preoccupation and resentment obscure our vision. Judgmental, cynical, and angry states of mind separate us from the richness of our world and cover over natural artistry. An angry mind may *seem* sharp, but it is a sharpness that is bewildering, lacking both insight and intelligence. Anger produces crudeness rather than artistry. An angry person is fixated on the object of his or her anger and blind to the details of experience and the environment. Anger overwhelms subtlety.

Possessiveness, craving, ambition, and other forms of desire cut us off from artistry because they are bound up with projections about objects of desire and possibilities of fulfillment. Being fettered in this way, we are unavailable to ordinary perceptions, and there is no room for the dance of creativity. Thus, even the desire to be artistic and creative can become an obstacle when we fixate on it. This is not to say that passion is necessarily a problem. The basic energy of passion, when it is not bound up with projections, brings out and energizes inquisitiveness and natural creativity.

Ignoring experience, however we go about it—dreaminess, dullness, laziness—is the emotional equivalent of putting out the DO NOT DISTURB sign. No fresh perceptions or inspirations are welcome. Needless to say, ignorance is an obstacle.

These various types of emotionality are like billowing clouds that block the sunlight. Sometimes they erupt in damaging storms. Other times they are like long spells of wet, gray weather.

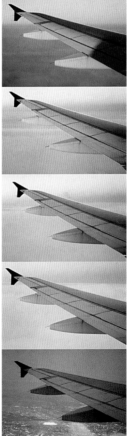

A different type of obstacle is the ongoing internal narrative that accompanies us from the moment we wake up in the morning until the moment we fall asleep at night (even reappearing in our dreams). Sometimes this narrative is a monologue, sometimes an inner dialogue. Always, the "voice" *seems* to be the observer, looking out at the world. But what this discursiveness really does is fill up space, leaving little room for creativity and shutting out most of the light. Contrary to the way it seems, the inner narrator is more like a talkative blind person than a skillful observer. Occasionally there is a break in the discursive flow and a fresh perception gets in, but whenever this happens, the inner narrator quickly jumps in and smothers that perception, wrapping it in commentary until all freshness is lost.

Struggling with these various emotional and discursive clouds is a losing proposition. It only adds to their energy and solidity. There is also no way to really suppress them. Surprisingly, the best way to deal with these obstacles is to recognize whatever they are and let them be. A light

Andy Karr, 2005.

touch of awareness, repeatedly applied, cuts the momentum of emotions and discursiveness. Trying to get rid of them just leads to more struggle.

You can become skillful at developing this light touch of awareness, and this is a key to living artistically. Another key is learning to recognize naturally occurring breaks in the clouds: moments where the light naturally shines through. The more you cultivate these gaps, the longer they will last and the more opportunity you will have to settle into your experience and creatively engage with the world.

There are things you should cultivate to enhance these experiences. The most important is an inquisitive mind. You can be inquisitive about your confusion as well as what lies beyond confusion, the world of ordinary, fresh perceptions. The more curiosity you have, the more you will be available to your experience and the more you will see. Cultivating patience will also be a great help, since unraveling the layers of confusion that have accumulated over a lifetime is a gradual process. Finally, nurturing a sense of humor is essential. Our emotionality plays games within games to perpetuate itself. You can't help but get sucked in. If you take the whole thing too seriously, you'll be dragged down into the maelstrom. However, just one moment of seeing the irony of that situation brings you back to the surface. *Phew!*

Art in Everyday Life and Everyday Life in Art

Seeing the ordinary world clearly is a source of raw material and inspiration when you work with your camera. If art is life experience expressed through creative technique, photography is one method for concentrating those experiences into images. You don't need a lot of craft or technique to produce fine photographs. When you experience your world clearly, and you shoot what you see, the results will be artistic.

Training in artistic living will enhance your photography, and training in contemplative photography will deepen your ability to live a creative, artistic life. As the wonderful photographer Dorothea Lange said, "The camera is an instrument that teaches people how to see without a camera."[2] The practice of contemplative photography will definitely increase your appreciation of the world around you, which is infinitely richer than you could ever imagine.

The photographs in the following pages of this book were taken by the authors, their students, and their friends. They have been chosen to illustrate the subject matter of the various chapters. These images show just how rich and fresh the most ordinary things—a silverware drawer, a doorway, bathing implements—can be.

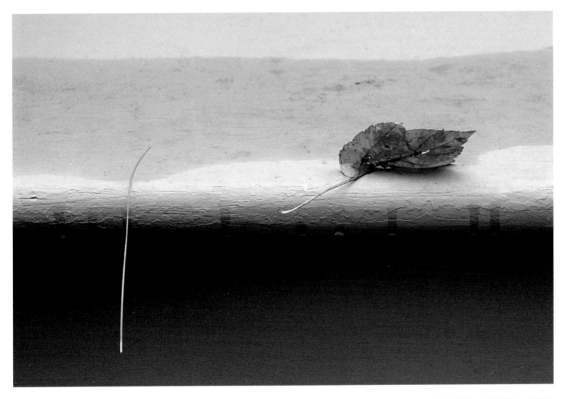

Michael Wood, Halifax, 2005.

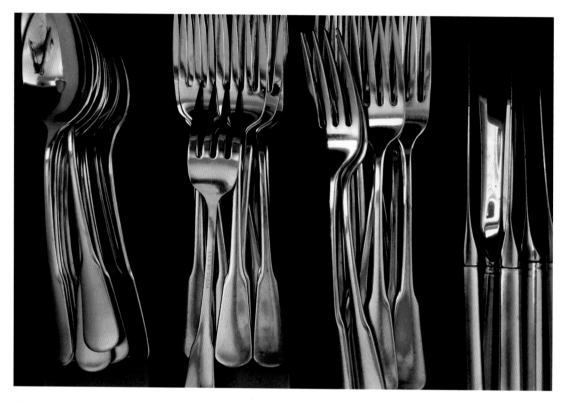

Michael Wood, Boise, 2009.

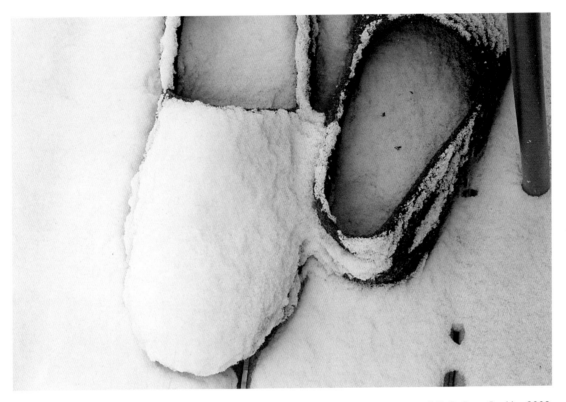

Julie DuBose, Boulder, 2008.

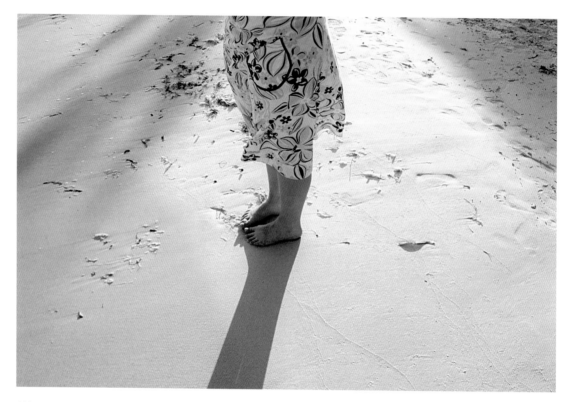

Alden Karr, Chuburna, 2008.

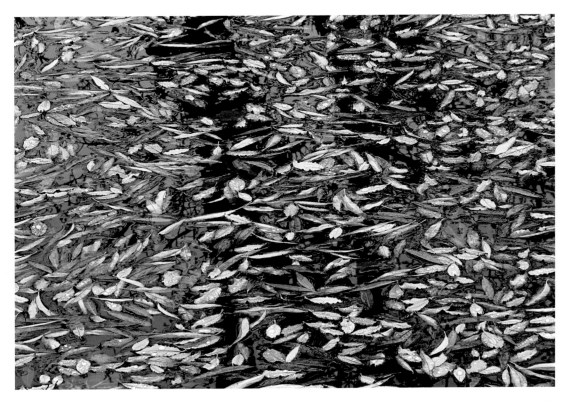

Michael Wood, Boulder, 2009.

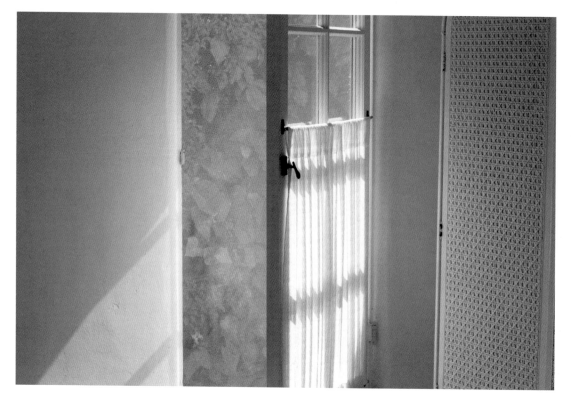

Michael Wood, Los Angeles, 2008.

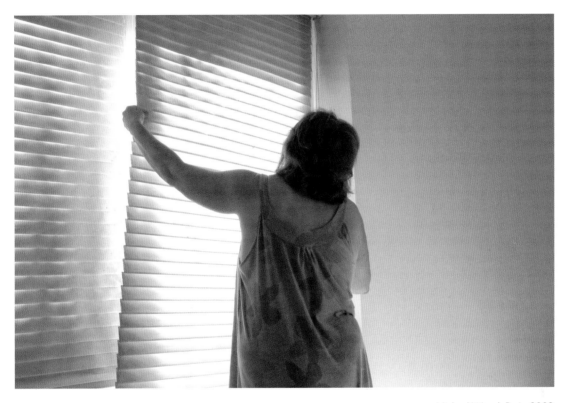

Michael Wood, Paris, 2009.

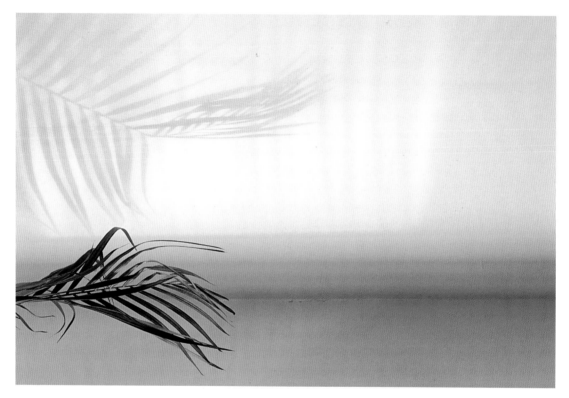

Andy Karr, Halifax, 2007.

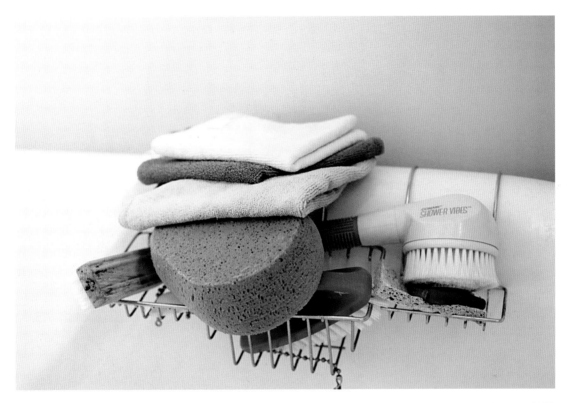

Andy Karr, Granville Ferry, 2009.

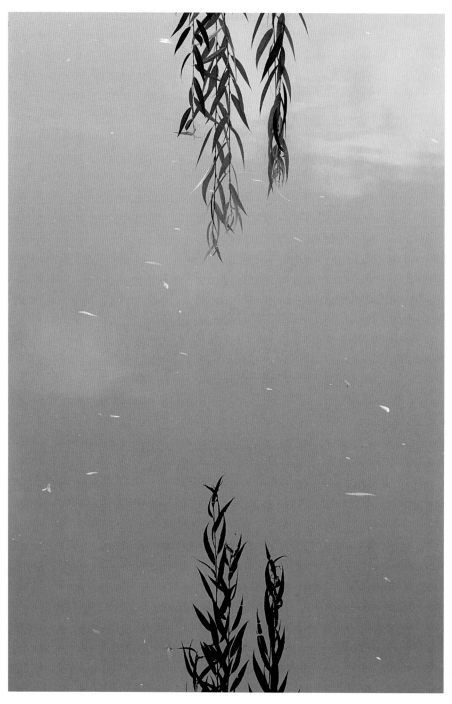

Michael Wood, Boulder, 2009.

3

TWO WAYS OF SEEING

We use the term *seeing* a lot when we discuss contemplative photography, and it would be good to clarify what we mean by that. Ordinarily, seeing refers to a broad range of experiences: from barely noticing to complete immersion in the visual realm. At one extreme, you could be driving or walking along, talking with friends, and then you see a red light and come to a stop, all without interrupting the conversation. At the other extreme, you could be stopped at that red light, and then *see* it—you see brilliant, saturated color, the patterns formed by the facets of the lens, the red glow cast by the light on the orange housing, and the light blue sky that surrounds the whole thing. From a purely functional point of view, these two instances could be described in the same way. In each case you have seen a red light. From an experiential point of view, they are worlds apart.

When you notice the traffic light, what is happening is primarily *conceptual*. When you see that same light, what is happening is primarily *perceptual*. When we use the term *seeing*, we are pointing to this perceptual experience. The world of direct perception holds richness and detail that is totally lacking in the world of conception.

The process of perception is subtle and complex. Usually perception and conception are blended, which makes it hard to distinguish the two. For example, as you are reading these words, you *perceive* the shapes of the words and letters. You also *conceive* of the sounds and meanings of the words. Reading is primarily conceptual. In fact, it is often hard to see the forms of the letters clearly because the habits of conceiving are so strong. If this writing were in Tibetan or Aramaic, you would see the shapes of the letters but wouldn't experience it as sounds and meanings (unless you had learned to read those languages).

Another example of mixing perception and conception is what happens when you watch a movie. When you watch a movie, you see light reflected from the screen and hear sound coming from speakers, but you conceive of people and places. The effect of these conceptions is so powerful that you engage emotionally with them, the way you do with real people. You will even conceive of personalities for characters in animated films where there are no images of people at all—think of Mickey Mouse or WALL·E.

Distinguishing Perception from Conception

To see clearly, you need to untangle perception from conception. To distinguish them, you need to take out your (metaphoric) microscope and look closely at each one.

If you bring to mind the tall buildings of New York or the Eiffel Tower, an image will appear to your mind's eye. That image is not the same as the visual image that appears when you look at the actual Manhattan skyline or the structure in the Champ du Mars with your physical eyes. The mental image is vague. The image that appears to the physical eye is specific. It is minutely detailed and complete. Mental images are like indistinct replicas of actual seeing.

To contrast perception with that, look straight ahead in a relaxed way, without labeling or conceptually identifying anything. It doesn't matter what you are looking at or whether you are inside or outside. You can do this anywhere. Gaze steadily in one direction, without moving your eyes, and become conscious of the different areas of your visual field. To put this another way, gradually become aware of different parts of your field of view without shifting your gaze. Start with the upper part, then move on to the lower part, then the right side, and then the left side. After that, just be aware of the whole visual field at once, without fixating on anything. That is perception.

Visual images appear when consciousness connects with the eye. Mental images appear when consciousness connects with the conceptual mind. What appears to conceptual mind is only an abstract, general image that encompasses all the views and pictures of a thing that you have ever seen. It is a very different kind of object from the specific ones that appear to the nonconceptual senses. The visual object that appears to the eye appears clearly, in great detail. You see—all at once—color, shape, texture, and the rest. This is true for the objects that appear to the other senses as well: the sounds that appear to the ear, the smells that appear to the nose, the tastes that appear to the tongue, and the tactile sensations that appear to the body. Each of these is experienced vividly and completely in an instant.

The usual sequence of perception is that in the first moment, there is direct sensory experience. In the second moment, a concept and label arise, superimposed on the direct

perception. The vivid perception is obscured by that concept and label. Instead of seeing, hearing, or tasting the clear, specific thing, you experience the conceptual replicas, as though you were seeing the original perception through a cloudy filter. These moments of perception and conception are extremely brief. The sequence happens very quickly, so quickly that you don't notice that a whole process is unfolding.

When you look at a vase full of irises, in the first moment, you see them clearly and completely. In the second moment, those luminous blue and yellow flowers are covered over by concepts and labels, for example, the thought "nice flowers" or the embryonic desire to possess them. When you taste delicious food, in the first moment, the taste is complex and brilliant. In the second moment, that vivid taste is covered over by the thought, "This is yummy!" In the first moment you are perceiving, but quickly this turns into conceiving. This is generally what happens when we notice something. The thing itself becomes vague as you lose contact with the vividness of direct experience.

Liftoff

Following this, you might let go of the concepts and float back to sensory experience. Alternatively, thoughts might proliferate and take you off to conceptual realms. While looking at the irises, you could start to think about where they were grown, who bought them, and how nicely they are arranged; while eating the meal, you may wonder who cooked the delicious food, what ingredients were used, and how it was prepared.

Often these conceptual journeys will take you into the future, where you find yourself involved in all sorts of plans and anxieties. Some might be quite elaborate. For example, you might spend a long time thinking about how to handle a project you have been working on. Or the conceptual journey might be quite simple, such as wondering where you should eat lunch. In either case, the concepts will take you away from the present and distance you from the vividness of your immediate experience.

Sometimes you will find yourself caught up in thoughts of the past. These could be brief memories, like remembering that there is no fruit in the house and that you need to buy some apples when you go to the store. They could also be long, absorbing recollections, filled with mental images of other places and times, such as revisiting somewhere you vacationed as a young child. Journeys into the past also take you away from the brilliance of present perception.

Sometimes you will find yourself daydreaming, deeply involved in imaginary activities that have nothing to do with past, present, or future. Sometimes when you take off, you won't find yourself anywhere at all! You will be lost in space, and everything will be vague and uncertain, like moving about in dense fog.

Wherever you go, it can be compelling. It is easy to get absorbed in these realms of imagination and completely lose contact with the ground of direct perception. However, most of these excursions are unnecessary. Their only function is to insulate you from the vividness of life and from your own heart. When you are lost in thought, simply recognizing the thinking once or twice will bring you back. It generally doesn't take much more than that. If you can't let go of a particular train of thought, just let the thinking exhaust itself. It always will.

Concepts are useful. Without them, you wouldn't be able to arrange to get together with friends for dinner, use a computer, or read this book. Abstract thinking can help you navigate the complexities of life, just as maps help to navigate to new physical destinations. But concepts can also blind you to what is vivid and real. If you can't distinguish conceiving from perceiving, you might be looking at the map instead of the road. Not only is it dangerous to drive with your eyes glued to the map—you will also miss the beauty of the journey.

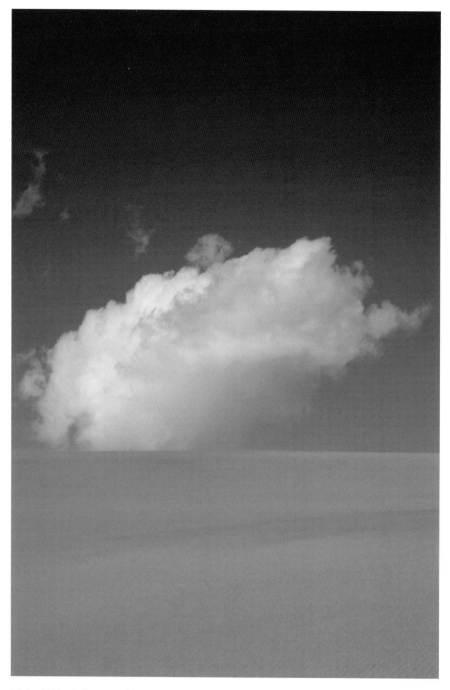

Michael Wood, Crestone, 2007.

4

THE PRACTICE

Contemplative practice requires a basic shift in allegiance. Normally we ally ourselves with thinking-mind: we obediently follow wherever it leads. When we think about going out for dinner, we soon find ourselves walking out the door (unless a contradictory thought intervenes). Sometimes, emotions well up and we follow them, no matter how much thinking-mind protests. Thinking-mind is like a political leader, and the emotions are like subversives that undermine the leader's authority. These seem to be our only possibilities: to follow the leadership of thinking-mind or go along with the flow of the emotions.

The contemplative approach presents an entirely different alternative: we can align ourselves with intelligence that is not bound up with either thoughts or emotions. This intelligence is called insight, mindfulness, awareness, wisdom, and so on. (In the traditional Zen analogy, these terms are all different fingers pointing at the same moon.) This intelligence is knowing-mind, which is neither conceptual nor emotional. It exists within each of us but is covered over by discursive thinking and emotionality. Fortunately there are natural gaps in these coverings where the wisdom can shine through. In contemplative practice, we work with these gaps and shift our allegiance to this intelligence.

The practice of contemplative photography connects us with this nonconceptual awareness and strengthens that connection through training. The practice itself has three parts, or stages. First we learn to recognize naturally occurring glimpses of seeing and the contemplative state of mind. Next we stabilize that connection through looking

further. Finally we take photographs from within that state of mind. In our contemplative photography terminology, these three stages are called

- connecting with *the flash of perception,*
- working with *visual discernment,* and
- *forming the equivalent* of what we have seen.

The Flash of Perception

As you go about your ordinary activities, there are sudden gaps in the flow of mental activity, and there you are. In those moments, preoccupation dissolves and fresh perceptions appear. These perceptions seem to come out of nowhere. You could be doing anything—working, shopping, having a conversation—and a flash of unconditional perception could arise. Suddenly you see ice cream, the sidewalk, or the color red. At first the experience of the flash is based on the contrast produced by the natural gaps in the flow of thoughts and emotions. You have probably had the experience of going for a long walk or drive, and suddenly you realize you've been so wrapped up in thought that you haven't noticed any of the passing landscape. That moment of coming back from distraction provides the contrast between being absent and being present, between being asleep and being awake, between thinking and seeing.

When the flow of ordinary mental activity is interrupted, mind and eye stop. The continuity of conceptual mind is broken. This might come as a shock, like being awoken from sleep by a loud noise. You wake up, and your surroundings appear vividly. This is what we call the flash of perception. Usually experience seems to unfold linearly. Each moment is woven into the next by threads of discursive thinking. The flash of perception is nonlinear. It comes from nowhere, and it goes nowhere. You are shocked from your sleep and lose your place in your story line. You are really *here.*

In the flash of perception, direct experience is not covered by the usual projections and concepts. There is space for things to come to you. Experience is definite, because there is no doubt about what you are seeing, whether it is sunlight or water or a coffee cup. Whatever it is, it is *here.* You are *here,* and there is no doubt involved, no shakiness. The nature of each perception is sharp, with a brilliant, clear quality. The flash of perception is a moment of seeing that is one-pointed, stable, and free from distraction. Experience is not diffused or scattered or moving. It is direct and in focus. It is stable because it is not tossed about by winds of thought or emotion. There is stillness and groundedness as awareness remains with perception.

Flashes of perception are unfabricated. They happen naturally. You cannot make them happen, but you can learn to recognize them. This is the first part of contemplative photography practice: learning to tune in to the flash of perception. The key to recognizing flashes of perception is to have a firm intention to notice the gaps in the discursive flow rather than gliding over them. We will present exercises and assignments later on to help you deepen your experience of the flash of perception and strengthen the intention to recognize it.

Visual Discernment

The second part of the practice of contemplative photography is visual discernment. Engaging the flash of perception is not difficult. The potential for clear seeing is inherent and natural, not something you have to struggle with or make up. As well, the craft of photography is not rocket science. Anyone can master the basics fairly quickly. Many students have done so. Even those with no previous experience quickly learn to express their perceptions clearly, vividly, and elegantly. The most difficult part of contemplative photography is visual discernment. This is the bridge between the freshness and vividness of the flash of perception and expressing that perception in a photograph. If you are going to express what you have seen powerfully and accurately, you need to be able to stay with the initial perception. Most photographers have had the experience of taking pictures of a strong perception and being disappointed by the resulting photographs. This happens when you lose track of the perception in the middle of the process.

Visual discernment is the way you maintain the contemplative state of mind after the initial flash of perception. The moment of the flash is free from discursive thought and its projections. Following this, the next stage of the practice is to rest with the perception in a soft, inquisitive way, without struggle. Then the contemplative state that *sees* carries right through to taking the picture.

Although we call it discernment, this stage is not intellectual or analytical in the conventional sense. It is not figuring things out or evaluating the scene emotionally. Rather, it is resting with perception and allowing the basic qualities of form to be recognized by innate, nonconceptual intelligence. There is a holding-still quality to this phase of the practice that allows things to emerge, rather than trying to interpret the nature of the perception or recall what you saw in previous moments.

There are two main obstacles to practicing visual discernment: excitement and photographic thinking. Often our first reaction to a flash is agitation. We have really

seen something! We have the prey in our sights! Excitement makes us lose contact with direct perception, and clear seeing gets lost in confusion. When this happens, try to recognize the confusion and let go of the excitement. If you can do that, you will be able to settle back into clear seeing like a leaf falling from a tree. If you can't settle into seeing, just let go and move on. You don't need to panic about not capturing the image. Although each perception is unique and will never occur in the same way again, there are endless fields of perception. Unconditioned perceptions are always available—it is just a matter of tuning in to them. Once you gain confidence in this, you will be able to relax into visual discernment and take the time to appreciate and express each perception completely, without anxiety. (You might also find it helpful to see the irony of being blinded by the excitement of seeing.)

The second obstacle to visual discernment is thinking about how to take the picture. The moment we think, "What would make this into a great image? What will this mean to people? Will they like it?" seeing ends and contemplative mind is lost. If you immediately set to work on techniques for shooting, projections and discursiveness will erupt and what originally stopped your mind and eye will be lost. Instead of reaching for the camera, this is a time for staying still. You don't have to freeze or enter a state of absorption. Just rest unmoving and unexcited with the perception.

It is possible to stay with (or return to) the flash—to just gaze in a very soft way—and by doing so, the actual visual aspects of the perception will emerge without confusion. Let the form itself suggest the composition. There is no need to add anything extra to make the perception better, and you don't want to omit anything that was part of the original perception. "Nothing added, nothing missing" is a good contemplative photography slogan. Continue to look.

We are describing this moment in detail; however, the whole process from beginning to end could take just a few seconds. In that time you could have a perception, discern what it is, take the picture, and be off. The idea of perception continuing right through the process is what is critical. The camera does not come into play at all during discernment. The act of reaching for the camera, in itself, can throw the process off, causing you to start thinking about zooming, exposure, composition, and so on. It's helpful to recall again what Henri Cartier-Bresson said: "Thinking should be done beforehand and afterwards—never while actually taking a photograph."

When you are satisfied that you have determined the nature of your perception, pick up the camera, frame, and shoot. If you can stay open and grounded as you perform the visual discernment, you will be able to take clear, fresh photographs of your perceptions.

Forming the Equivalent

The third part of the practice is forming the equivalent of your perception, or taking the picture. We emphasize the equivalence of the photograph and the perception because the two things are obviously different, but our aim is to produce an image that is comparable to what we perceive—nothing more, nothing less.

There is a crossover between visual discernment and forming the equivalent: you start linking your perception, your understanding of the perception, and your knowledge of the medium. Up to this point, you haven't touched the camera. It is good to keep that in mind. So far it is all working with eye and mind. At this point you have seen the subject clearly, without conceptual filters or discursiveness. You have rested with the perception in visual discernment, without agitation or photographic thinking. Now you use the camera to create the equivalent of the perception.

Forming the equivalent begins with choosing a framing that reflects the composition that was revealed during the visual discernment. Ask yourself if what you see in the viewfinder, or on the LCD, is just what stopped you, or if there is anything added or anything missing. You might need to move closer or zoom in to isolate just what you saw.

Forming the equivalent also involves choosing camera settings that will properly reproduce what you perceive. Some basic understanding of the craft of photography will help you express your perceptions accurately and elegantly. (We will go into this in chapters 13 and 15.) If you already know how to work with *depth of field, exposure,* and *color balance,* make sure the choices you make honestly reflect your perception. If these terms are unfamiliar to you, just rely on your camera's automatic settings for now.

This medium is capable of dealing with an extraordinary range of situations and, for the most part, will give you the ability to express your perceptions quite precisely. However, sometimes you will encounter perceptions that the medium can't properly handle. When this happens, just remember that there are countless other perceptions, and let it go and move on.

As you work with this practice, you will probably be tempted to try to improve your photographs by resorting to artifice. You might have some innocent little thought like, "If I underexpose this shot a bit, the colors will be more saturated and beautiful" or "If I use a really wide angle and shoot from below, this will look more dramatic." These thoughts might seem innocent, but don't do it! As soon as you start thinking about manipulation, you lose the freshness of the experience. The images that come from this will also lack freshness, immediacy, and aliveness. It will be like the experience of eating canned asparagus instead of asparagus that is brought home from the farmer's market

and cooked that very day. In contemplative photography the power of the final image comes from joining clear seeing with genuine expression, free from contrivance.

If we work with the three stages of the practice genuinely, when we finally pick up the camera and take the photograph, there's a link, or thread, that runs right through from the flash of perception to the final image. That gives the image the power and vividness to actually wake up the eye and mind of the viewer. As long as the thread of perception is there, then confidence and accuracy can run right through—right through the camera, right into the image, right into the eye and mind of the viewer.

Here are some images that will give you a feeling for the types of results you can get when the contemplative state of mind is continuous throughout the three stages of practice.

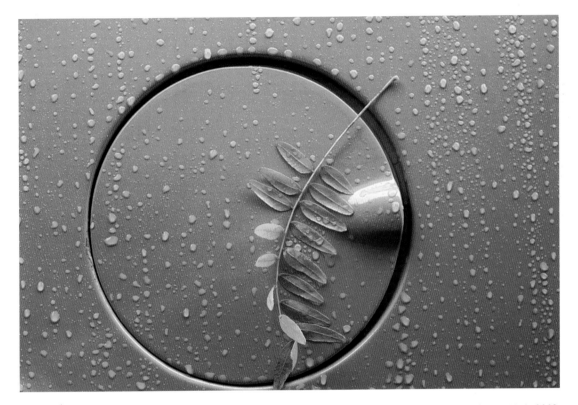

Michael Wood, New York, 2002.

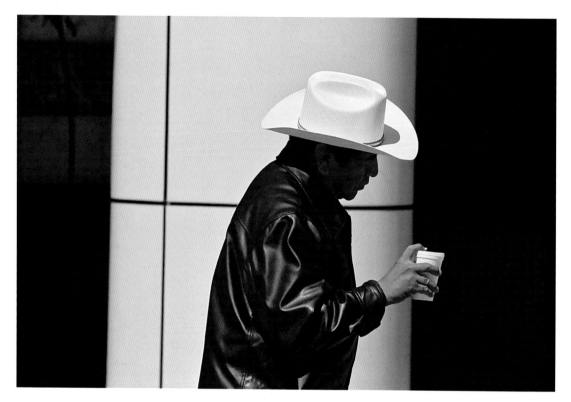

Michael Wood, Tucson, 2007.

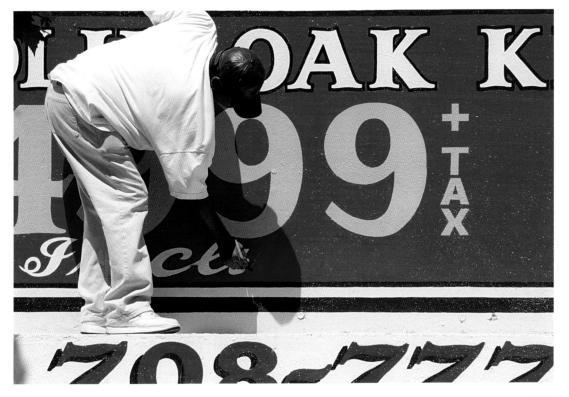

Michael Wood, Los Angeles, 2008.

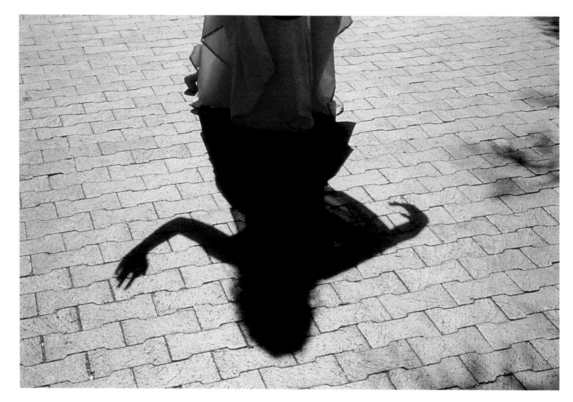

Michael Wood, Boise, 2005.

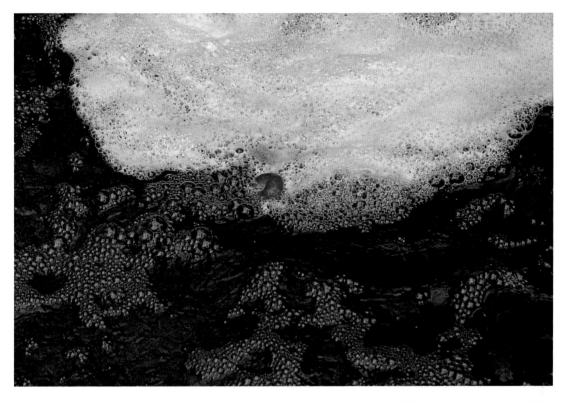

Michael Wood, San Francisco, 2006.

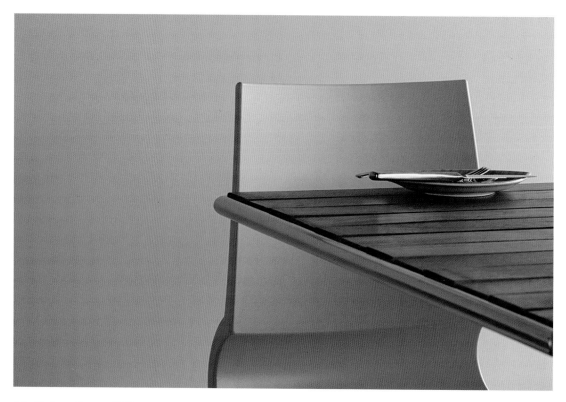

Julie DuBose, Denver, 2009.

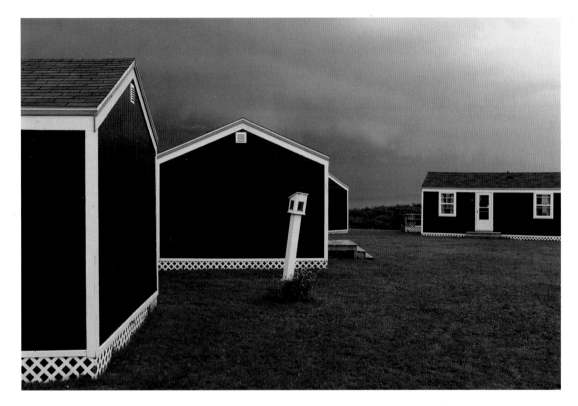

Andy Karr, Cape Breton, 2007.

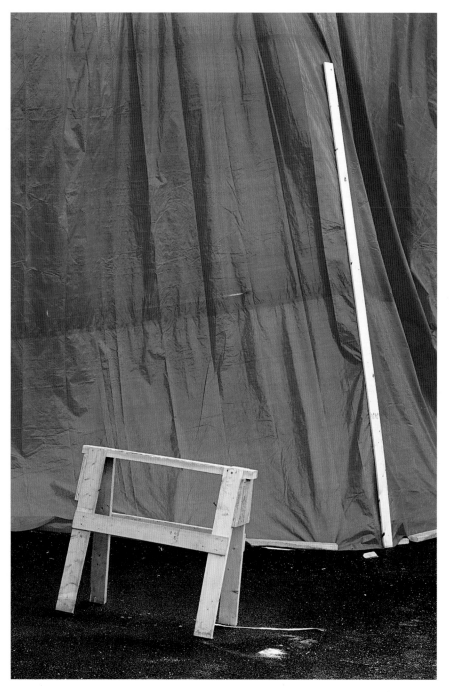

Andy Karr, Halifax, 2006.

5

GETTING STARTED

Even a casual approach to contemplative photography will introduce you to a new way of taking pictures and a fresh way of seeing. A serious commitment will transform your photography and the way you experience your world. It is up to you how deeply you want to engage this practice. If you want to make a transformative effort, a certain amount of discipline will be necessary, but it won't be as difficult as going on a prolonged diet or working out regularly at the gym. This practice is rewarding, sometimes frustrating, and often pleasing. That should help keep you going.

While you are learning the practice, we encourage you to go out with your camera two or three times a week. That seems to be what it takes for the practice to penetrate. If you can't practice that often, at least set aside a weekend morning or afternoon to go shooting. Having a regular rhythm is much better than practicing in fits and starts.

Before you go out, make sure your camera is properly cared for: that the battery is charged; that the lens, viewfinder, and LCD are clean; that the memory card is properly formatted. Each time you go shooting, make sure you have enough time to involve yourself fully in the practice. We recommend setting aside at least an hour or two at a stretch. It takes time to settle in and connect with seeing, and it takes time to learn the different elements of the practice, so give yourself time.

Begin each session by letting go of the things that insulate you from your environment. This might include unplugging yourself from the Internet, taking off the headphones, and turning off the cell phone. It means giving up conversing with friends while you practice. You also don't need to entertain yourself with a lot of thinking, planning, or daydreaming.

The contemplative state of mind is always free from preoccupation. It is mind that is

open and fresh, receptive to whatever arises. When you practice, cultivate this state. At first you might experience such freedom as boredom, discomfort, or loneliness because you miss the cocoon of your familiar activities. Many of us are not used to being alone and are addicted to regular stimulation and entertainment. This practice is an opportunity to make friends with yourself—unplugged. It doesn't take all that much time or effort. Solitude is the home of contemplative mind and the space where creativity flourishes. By staying with whatever discomfort you feel, you will quickly get used to being alone and begin to enjoy your own company and appreciate your independence.

Locations

There are lots of good places to practice. The main thing is not to look for locations that you think of as "beautiful" or "special" or "photogenic." In particular, try to avoid parks, gardens, and natural settings. We have so many concepts about "the beauty of nature" that it is extremely difficult for beginners to see nature as form, free of these concepts. Other than that, it doesn't really matter where you shoot, as long as you feel at ease. In the beginning, you might find that busy streets have too many distractions, too much noise, and too many people watching you. On the other hand, you might not mind these things at all.

Try to find places that offer a lot of visual variety. Industrial areas, pedestrian malls, and areas where there are lots of shops are usually good places to shoot. Your customary surroundings are also good. It is particularly rewarding to see familiar locations, like your house and your neighborhood, in fresh ways.

Assignments

In this book we offer a series of assignments for practice, beginning with a color assignment. The purpose of these assignments is to help you connect directly with the visual world and to express that experience photographically. Assignments provide specific intentions for you to work with. These intentions are like stop signs for conceptual mind. When you glimpse what you intend to see, thinking is interrupted, leaving a gap for perception to shine through. When you connect with the perception, it is experienced as a flash.

These assignments have been developed for the purpose of training and are *not* meant to suggest good subject matter for contemplative photography. They are only methods to help you align eye and mind. When eye and mind are aligned, *any* fresh, direct perception is good subject matter.

When you do this practice, no matter which assignment you are working with, remember that you are attempting to dissolve the way you label things and gloss over them. You are trying to dismantle conceptions, overlays, memories, and associations. You are trying to unglue, untangle, and deconstruct the world of form into its basic elements: color, light, texture, shape, line, pattern. When you look at things deeply, simply, with open eyes and a steady mind, that's all there is. Everything else is just an overlay, an idea.

COLOR ASSIGNMENT

Color is the most powerful and basic element of the world of form. It is the first assignment because color is easy to recognize and it sparks strong flashes of perception. It is an assignment you can work with over and over again, and we encourage you to do so. Color is pleasing. Color is not subtle. Color has no meaning, apart from what thinking-mind superimposes on it. Colorful *things* can have meaning—like a red mailbox—but red itself has no meaning. It is what it is. It is just basic appearance.

Shooting color gives you something to look for that will synchronize eye and mind. Your intention should be simple and clear. When you work with this assignment, keep a narrow focus on color. Look at color in a simple and open way. If you stray to other intentions, your shooting will become vague. When you see flashes of color—free from concept—eye and mind will be on the same axis.

Look at color out of context. Look as a little child would look: free from associations, memories, reference points, likes, or dislikes. Look at signs and billboards as color and form rather than words and messages. Try to avoid being caught by colorful objects, things that you think of as colorful. We can't stress that enough. Shooting colorful objects is giving in to the labeling process. Look deeper, more directly, nakedly. Try to boycott your conceptual knowledge about what you are looking at. Look at the world of color. See the redness of red and the blueness of blue without superimposing anything on them at all.

Red.

Blue.

At some point you will experience just flashes of color.

For each assignment in this book, there are written instructions and images that exemplify the intention for that assignment. The photographs are as important as the text. Try to spend some time with the images before you go out to shoot the assignment. You should have no doubt about what the dominant quality of each of the images is.

GUIDELINES FOR THE COLOR ASSIGNMENT

The following guidelines are not value judgments. They are practical instructions based on our experience of working with students. Try to stick with them. They will help you to see.

Things *not to do:*

- For the purposes of this assignment, black, white, gray, and beige are not colors. Look for bold, vivid colors.
- Do not shoot graffiti or graphic designs, even very colorful ones.
- Do not shoot words or letters or numbers.
- Forget about shooting flowers and nature.
- Do not shoot color from across the street, or up high, or from far away. Get in close, so that what you see in the viewfinder or on the screen is just what stopped you.
- Do not include anything extra.

Things *to do:*

- Be clear about the assignment and the intention to shoot color.
- When you are stopped by a flash of color, just let your mind stop.
- When you are stopped by a flash of color, stop physically. Spend half a minute looking further, contemplating what stopped you, without lifting your camera.
- Understand what you see: Where does the perception start, and where does it end? What's included and what's not? Is the perception vertical or horizontal?
- Raise your camera and look at your perception through the viewfinder or on the screen. Ask yourself if this is what stopped you.
- Make any necessary adjustments to exposure, focus, and depth of field.
- Release the shutter.
- Enjoy yourself!

Remember, there are infinite perceptions. When you find yourself struggling to take a picture or you lose track of what stopped you, walk away and start over.

AFTER SHOOTING

When you have finished shooting, keep looking! Sometimes it is only when you put the camera down and relax that looking turns into seeing. Try to maintain a light intention to look and see.

When you get home, take time with your images. Don't rush to pick out the good shots and reject the bad ones. Try not to be harsh or judgmental with yourself, but keep looking. Recognize what you have and try to see what worked and what did not. When you have a good sense of that, delete the images that did not come from real flashes of perception.

Sometimes you will want to hang on to pictures that don't quite make it. That's okay. You might need to give it some time before you are ready to let them go. The main thing is to take your time and be honest with yourself about what is fresh and what is not. It is not unusual to have to throw away three-quarters of your shots when you are starting out. That is how you will learn.

The following images are good examples of color-assignment shots.

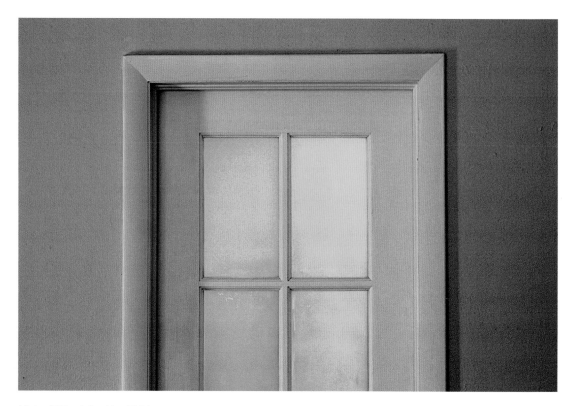

Michael Wood, Boulder, 2006.

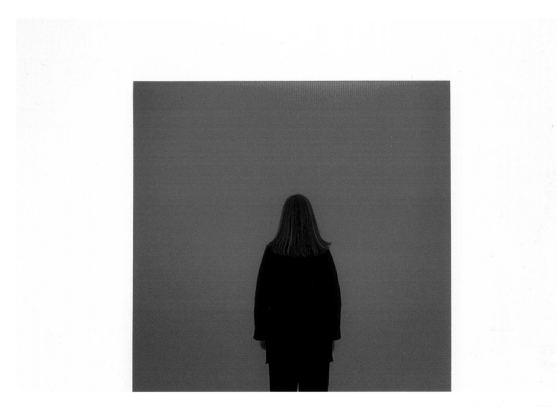

Andy Karr, Ottawa, 2003.

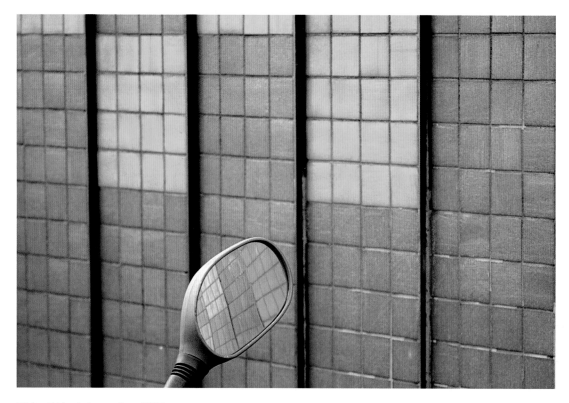

Michael Wood, Amsterdam, 2007.

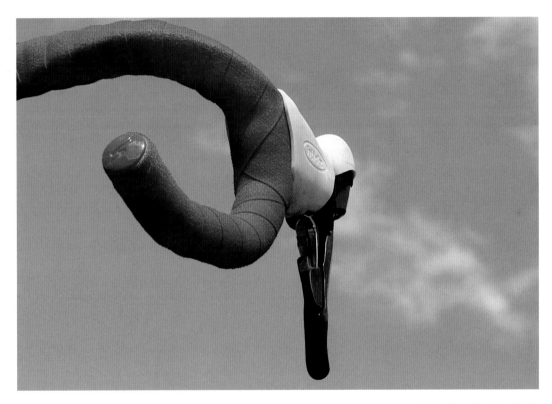

Julie DuBose, Boulder, 2009.

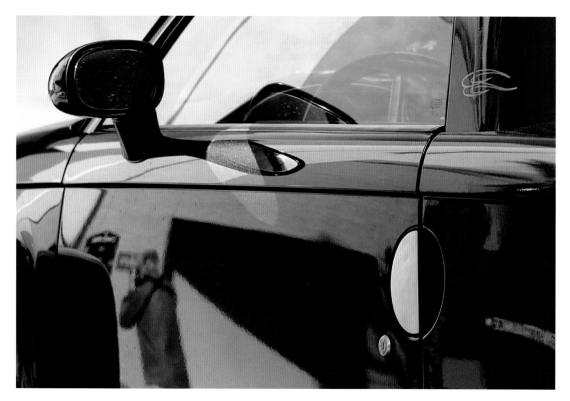

Michael Wood, Tucson, 2008.

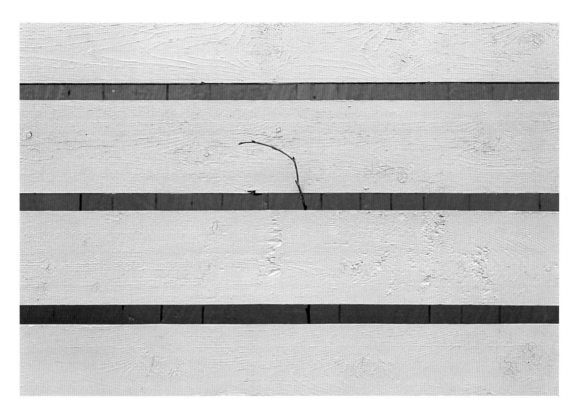

Andy Karr, Halifax, 2006.

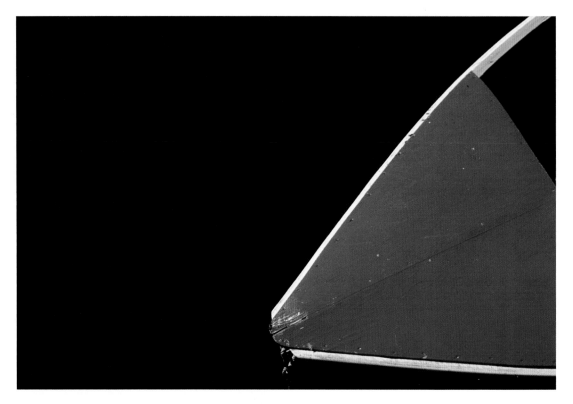

Andy Karr, Halifax, 2002.

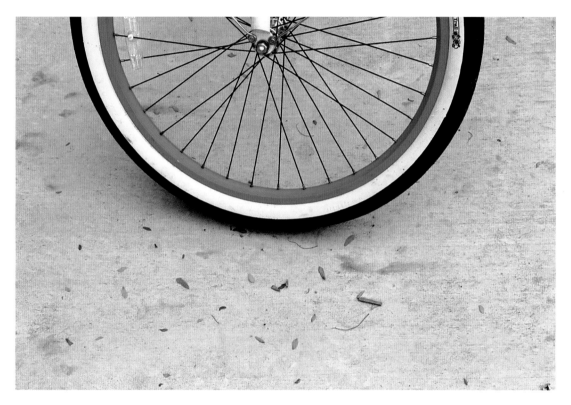

Michael Wood, Boulder, 2009.

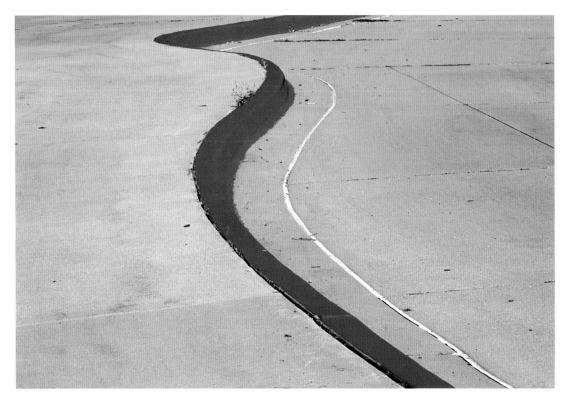

Michael Wood, Boulder, 2008.

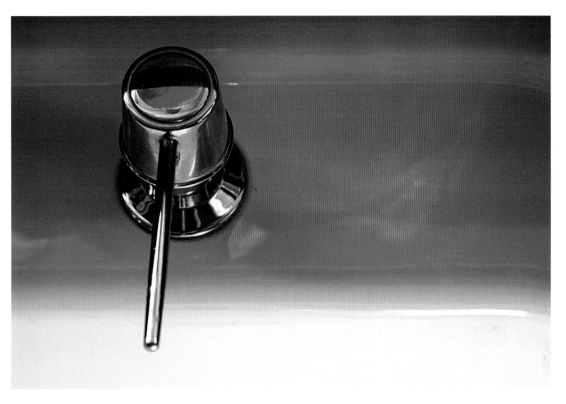

Michael Wood, Boulder, 2009.

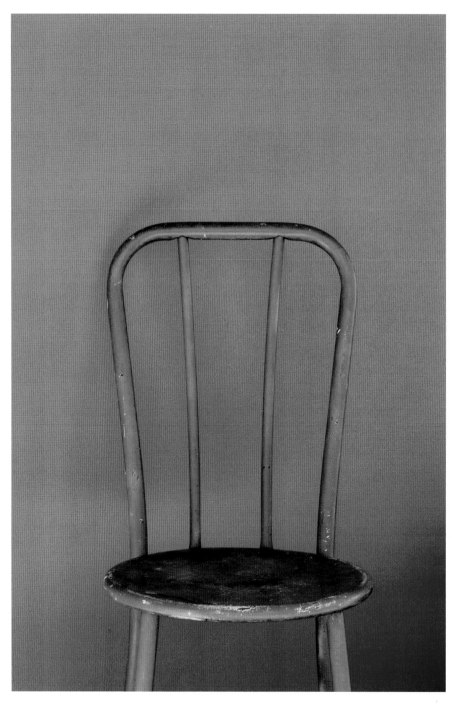

Michael Wood, Tucson, 2006.

6

SYNCHRONIZING EYE AND MIND

When you go out to shoot, just thinking about taking pictures brings up expectations: what you want to see, what you don't want to see, where you'll find something, and particularly, hopes for some really good shots to show your friends at the end of the day. All of these thoughts will cause apprehension that will prevent your mind from settling and your eyes from seeing. It won't help to try to push the thoughts away. Just acknowledge them, and once you've done that, let them go and start to work with eye and mind.

RESTING IN THE PRESENT

One way to begin is by walking slowly, being mindful of the sensations of your body as you move. You could also listen to sounds without labeling what you hear. You could look in a relaxed way at everything you come across, trying not to focus on the highlights. There are many ways to ground the mind in present experience. The more your mind rests in the present, the more you will see.

Try looking at the pavement, noticing the textures of the flat surfaces as well as the cracks. Look at what is boring as well as what is interesting. Let your eyes rest in their sockets, but keep moving and looking. Wander around and look at whatever crosses your path. Don't skip over things, and don't start to shoot. At this point just rest your mind and tune up your eyes. If you start taking pictures too soon, it will stir up more expectations and distractions. It could take ten minutes or more for mental activity to slow down and for your eyes to wake up, so don't be in a hurry.

VISUAL EXERCISE

Another way to start out is to use a visual exercise to help synchronize mind and eye. Here is one that is particularly suited to working with the color assignment.

Find an open place with lots of visual variety; for example, an empty parking lot surrounded by busy streets, or a square bordered by shops and buildings. You could even try this indoors in a decent-size room. Pick a spot and stand still. It is important to stay in one place. Don't wander around. You are going to look for color. Not colorful *things*, just color. To help form the intention, think to yourself, "I am going to look for color."

Begin the exercise by *slowly* turning around through 360 degrees. It should take you about a minute to make a complete rotation. As you turn in place, notice all the colors that your gaze passes over. The entire time you are turning, just look at color—pure and simple. Look straight ahead at color that is at eye level. Then look for colors that are higher up. Then look downward at colors that are below eye level. Just notice the colors you see, without naming them, and keep turning in place. Look with a light touch: touch and go.

Try not to read signs or think about the meaning of anything you see. If you see a blue car, try to stay with just the blueness of the form. You don't need to label it as a car, or identify the brand, or think how cool it is, or wish you owned it. Just touch and go. If you find you are lost in thought, let that go and continue to turn and look.

After you have made several rotations, stop and ask yourself the following questions:

- How did it feel each time you noticed color?
- Did the experience change when you began to think about what you were seeing?
- Did new and more subtle colors present themselves as you continued to rotate?
- What was the experience of seeing like?
- How did you feel after the exercise?

Now do several more rotations and again ask yourself the same questions.

When you have finished, if you noticed more and more color each time you turned around—how did that happen? What does that say about awareness?

At some point when you are doing the exercise, you will begin to notice that you are seeing color without labels, and you will be able to connect simply with what you see without a lot of thoughts. At that point mind and eye are synchronized. Your senses will feel alive and energized. Your mind will feel relaxed and awake.

AIMLESS WANDERING

Now that you have settled, you can begin to shoot. Start by wandering without any idea of a destination. Don't search for something to photograph, but wait for flashes of per-

ception to come to you. Be patient. Recollect the assignment: color. If you relax and keep moving, flashes of color will appear.

Try to find a relaxed groove where you experience a flash, hold still and look further to discern what the perception is, and mindfully make the image, relaxing through each stage of the practice. As you get into the rhythm of this, preoccupation will fall away and seeing will become more accessible and continuous.

When you begin to shoot, sometimes you might feel trigger-happy—so eager to take a picture that you start raising your camera to your eye just to look through the view-finder. You might feel numbness in your eyes from straining too hard. You might be anxious about not being able to see anything at all. These are things that come up when you are not used to such an open-ended practice and when you start to experience freedom from occupation. Feel the emotional texture of whatever comes up for just a few moments, whether it is agitation or depression, and return to the assignment. If the feeling persists, you might need to walk it off. Forget about shooting for a few minutes and stroll, feeling the movement of your limbs, listening to the environment, looking about in a relaxed way. When you settle down again, start working on the assignment.

Working with Emotional Swings

As you practice, there will be ups and downs. You will experience flashes of color and get so excited that you start shooting away, forgetting all about visual discernment and forming the equivalent. As you get wound up, you might think that everything you notice is a flash of perception and fire away at everything that you see. On the other hand, you could go for quite a while without experiencing any flashes and get frustrated, thinking you will never be able to see anything at all. This is practice. Practice means learning to work with all of these states of mind and continuing to refine the three stages of the technique. When you are practicing, don't worry about how many good shots you get; what matters most is how you train eye and mind.

One way to reduce the emotional swings is to linger a little over each shot. After releasing the shutter, most of us have a tendency to stop looking; we quickly review the image and get on to the next thing. Rather than rushing on, look through the viewfinder for a moment or two after you have taken the picture. If you are shooting with the LCD, you can lower the camera and look at the scene directly for a moment or two before reviewing the image. This method will be like having little speed bumps to slow you down and keep you grounded.

Try to find a balance between being too tight and being too loose. If you make too much effort, you will get wound up. If you make too little, you won't connect with the

contemplative state of mind or master the practice. If you can enjoy yourself with whatever you encounter, it will be easy to find that balance.

Give Yourself a Break

After you have been shooting for a while, maybe forty-five minutes or an hour, take a break. Have a coffee or sit down on a bench and relax. Sometimes, just when you put down the camera, looking will become seeing. Suddenly you notice rainbows in the bubbles of foam in your cappuccino or the color of the sky shining in the ice cubes of your club soda. At such moments you will really appreciate the richness of this colorful world. These are examples of the kinds of perceptions you might have when you really loosen up.

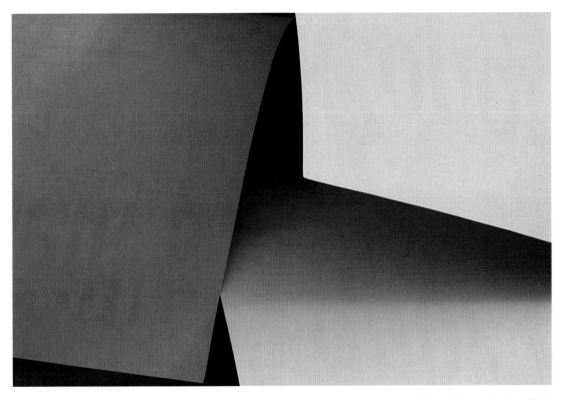

Michael Wood, Boulder, 2008.

Julie DuBose, Amsterdam, 2009.

Andy Karr, Halifax, 2008.

Julie DuBose, Boulder, 2009.

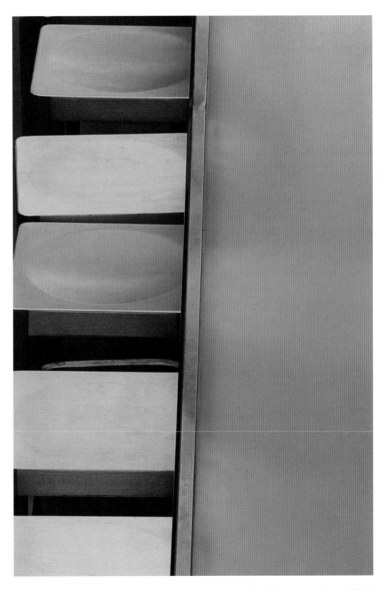

Julie DuBose, Las Vegas, 2009.

Whit Jones, Tucson, 2007.

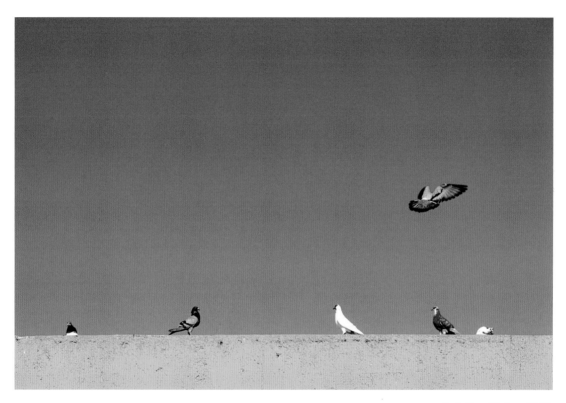

Andy Karr, Chelem, 2009.

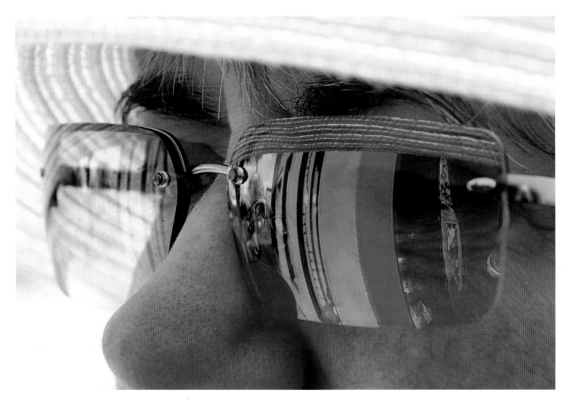

Michael Wood, Tucson, 2007.

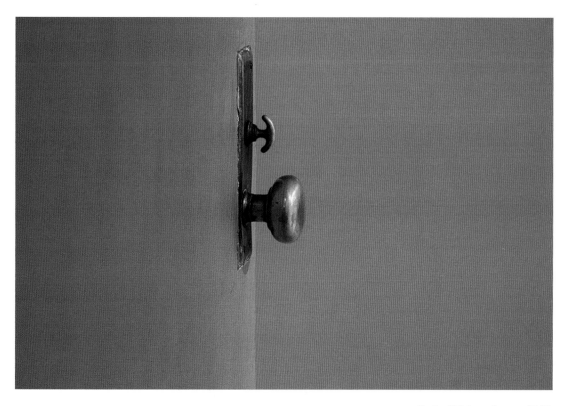

Genice Wickum, Sonora, 2008.

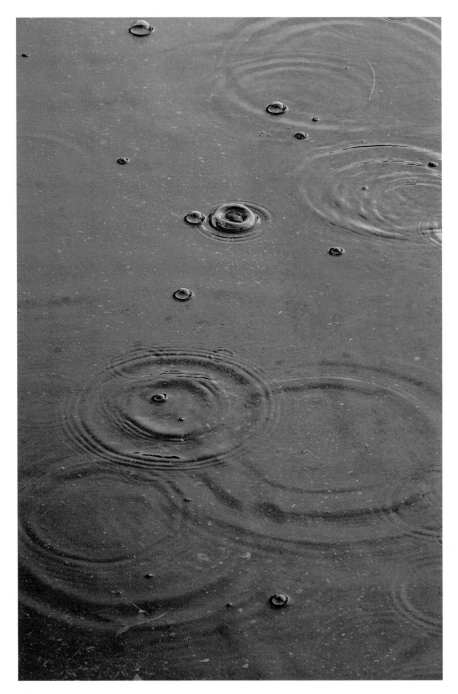

Michael Wood, Boulder, 2007.

7

LIFTING THE VEIL OF BOREDOM

After you shoot the color assignment a few times, you might get bored and long to move on to the next thing. Your initial enthusiasm for shooting pure form could give way to thinking there must be more interesting subjects to shoot than color, subjects that are more evocative, cool, and different. "I have seen red and blue and so on. I've seen it all. What's next?" At this point, don't be seduced by thoughts that there are better things to shoot in Point Lobos or Tuscany, better photographs to be made of landscapes or people. Boredom is merely a symptom that you haven't opened your eyes wide enough.

If you can relax fully into the present moment and keep a strong intention toward seeing color, there is no limit to what you can see. It is endless. You could explore color or texture or light for the rest of your life and never see all of it, never exhaust the intricacies and depths of the world of form. With an open, restful, still mind, there is no end to seeing, no limit.

When you become bored with the simplicity of form, it means you are still on the outside looking in—separate from the objects of perception. This might be because you are photographing for an audience, which makes it hard to appreciate what is right in front of you. When you shoot to get the approval of someone else, you will always be evaluating what you see with your audience in mind, not experiencing the brilliance of your own perceptions. There will be an ongoing stream of judgmental thoughts: this is pretty and this is ugly, this will make a good photograph and this won't, this is exciting and this is boring. These opinions close you off from the world of direct perception. It takes some exertion to push past what you think, especially when you think you've seen it all, but you can do it.

THE TWENTY-SHOT ASSIGNMENT

The twenty-shot assignment is an opportunity to open your eyes really wide and continue to train in the three stages of the practice. In this assignment you will explore a subject thoroughly, a subject that offers *nothing* in the way of conventional photographic interest (we are not kidding).

Here are the subjects you can choose from:

- A garbage dumpster
- A car
- A section of sidewalk
- A parking meter
- A fire hydrant
- A garage wall
- Your kitchen sink

Whichever one of these subjects you decide to work with, it is going to seem ridiculous. Bear with us. The point of the exercise is that you can go beyond limiting ideas of interesting and boring and find fresh perceptions anywhere. If you doubt this, just remember what Edward Weston discovered shooting peppers.

To start the assignment, put your camera aside so that you won't be tempted to use it to make things look interesting. This is work for your eye and your mind. Begin by looking over your subject in a relaxed way. Don't look for anything in particular, just look into the basic forms of whatever it is. Look at color, texture, pattern, and line, as well as the way the light falls on it and the way it changes as you move. These are the basic elements of form.

Spend about a quarter of an hour exploring the subject in this way. Look slowly, carefully, completely. Look without thinking about what might make a good photograph. If you get antsy, just notice those feelings and continue to look. It's okay if you think this is a crazy thing to be doing (and you would rather be doing anything else in the world, even shooting color). Let those thoughts bubble up and dissolve without being led astray by them. If you find you aren't seeing anything, or you really hit a wall, turn away from the subject for a minute or two and relax. Then turn back and begin again. When you get really bored, close your eyes for a few moments, then open them quickly and notice whatever appears.

After you have explored your subject well, pick up your camera. Briefly recollect the three stages of the practice and then begin to photograph what you perceive. Don't try to take pictures of what you saw earlier. Look in a fresh way, and shoot what you now

see. Take time to discern exactly what it is that you see, no more, no less. Carefully form the equivalent of your perception. Don't use a macro lens (or macro setting) to get extremely close and exaggerate little details. If you happen to notice a detail, use your camera to express it just as it is, in the context you perceived it. Continue to look, and see new aspects of form as they appear. Gradually, new perceptions will reveal themselves. If you get bored or tired, take a break for a few moments and begin again.

Try to take the attitude that there is nothing else to do, no other subject to see, no better place to be. Don't rush to complete the assignment so that you can do something else. Spend at least a quarter of an hour shooting and take at least twenty pictures. When you feel you have really explored your subject and expressed your perceptions accurately, step away from it for a few minutes and relax. After a short break, return to your subject again and find one more perception that you did not have before and make an image of it.

When you do this assignment, it's unlikely you will end up with brilliant images of a dumpster, but that's obviously not the point. We hope that you will see that boredom can be overcome and that looking into the most ordinary subjects can reveal all sorts of fresh perceptions. In fact, boring and interesting don't exist from the side of the subject at all. They only exist in the mind of the observer.

The montage on page 91 shows how diverse your perceptions could be when you thoroughly explore one object.

Boredom and Entertainment

Our culture continually tells us that boredom should be avoided and that entertainment should be sought out. However, no one ever explains why this is so. What is it about boredom that makes it painful? Why is it so compelling that we can't get in the car without switching on the radio, wait for an appointment without reading a magazine, or spend a tranquil evening at home without watching television or a movie? Why do we need to check our e-mail so frequently, continually text our friends, or waste so much time on Facebook? The basic question is, why can't we relax when we have nothing to do and enjoy a little bit of space in our lives?

The problem is that we are afraid of our own hearts. There are many, many things we haven't wanted to look at. The heart is so sensitive, so ready to resonate with the world, that we keep it covered, fearing we won't be able to stand being touched. It might be too intense. We might be overwhelmed. We can't afford to open up, because who knows what we might feel. It seems safer to armor the heart, even if that shields us from the vitality of life.

Boredom is a sign that your heart is about to be exposed. When you have nothing to do, whatever accumulated agitation, restlessness, or existential anxiety you might have begins to surface. You become aware of feelings that are normally submerged. Boredom is the forerunner of this distress and a signal that you should seek some diversion to hold your heart at bay.

In fact, you don't need to shield yourself. It is good to expose your heart. By exposing your heart, you begin to make friends with yourself on a deep level, and this will break the cycle of discontent and compulsion. When boredom arises, don't run away. Simply acknowledge the feelings and rest with whatever they are.

Exposing your heart is also exposing yourself to the richness of the world. The more you open your heart, the wider your eyes will open and the more you will see. With an open heart, you will appreciate more, and this will give you more to share through your photographs.

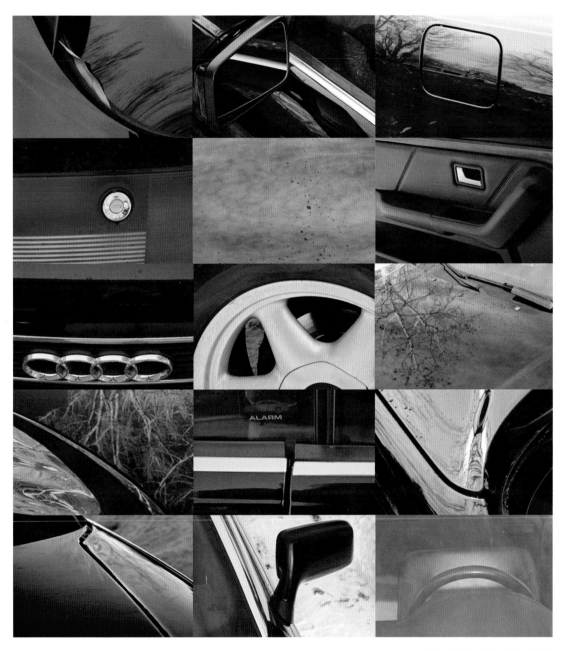

Michael Wood, Boulder, 2010.

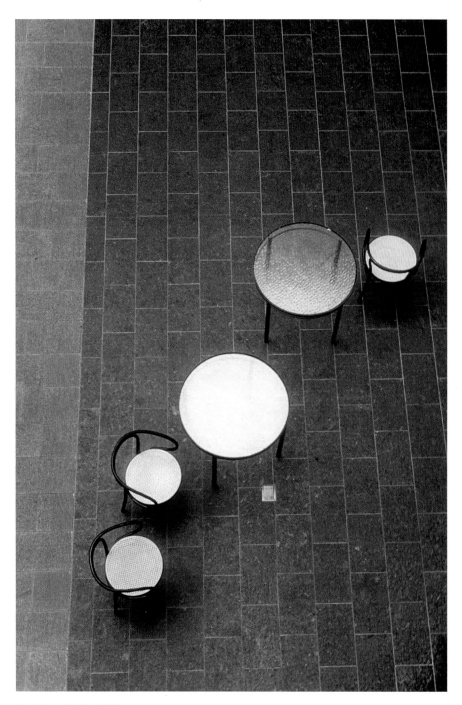

Andy Karr, Halifax, 2003.

8

THE FLASH OF PERCEPTION

Sometime you might have this type of experience: a close friend, a relative, or a spouse changes his or her appearance. He shaves off a mustache, she changes the way she does her hair, or the person simply gets a haircut. You see the person, and while sensing that something is different, you can't put your finger on what it is. You might not even notice that something is different at all. You are able to recognize this person effortlessly, even though his or her appearance has definitely changed. This is interesting. There must have been a moment of direct visual perception somewhere in the process, otherwise you would not have known there was another person present. But that perception is covered by the subsequent conception of that person's identity—my friend, my boss, my wife. You might be tempted to think that the first moment of seeing the person was a flash of perception—you did see something—but this experience is more like a flash of *conception*. That's what you related to: the conception of the person's identity.

Here is another type of experience. You look at a highly polished surface: it could be a windshield, a computer monitor, or a plate glass window. At first you see the interior of the car, the image on the monitor, or people eating in a restaurant. In the next moment, without shifting your gaze, you see a reflection of trees, your own face, or the sky. You didn't notice the reflections at first because you were trying to look at what was beyond the surface. Then the vividness of the reflected appearance broke through that effort and you saw. This is an example of a flash of perception.

The difference between these two experiences is that in the first one, there was no real break in the flow of thinking. In the second one, concepts ceased so that the light of basic intelligence could shine through, illuminating the world of perception. At that moment, eye and mind were aligned.

Flashes of perception occur only when there is a gap in the thinking process. They happen in natural breaks in the flow of conceptuality. These breaks take place all the time but generally slip by unnoticed. When we have the intention to recognize them, these breaks become much easier to spot. Sometimes a strong perception provokes the break, stopping conceptual mind in its tracks. Being stopped like this produces vivid perceptual experiences. At other times we just find ourselves relaxing into a feeling of being present.

Knowing what is, and what is not, a flash of perception is critical for the contemplative photographer. All of the rest of the practice hinges on that. Without aligning eye and mind, you are nowhere. Your eye might be looking over here, and your mind could be over there—labeling what you are looking at, commenting on it, recollecting other times and places, planning the evening's entertainment. You are somewhere else. When you bring eye and mind together and they are aligned, you might see dust motes in the sunlight, and that's a flash, or you might see trees receding in perspective along the sidewalk, and that's a flash.

Staying with the flash of perception has a quality of motionlessness. You are not distracted, jumping at every little thing that happens and getting caught up in it. This is part of the flash of perception. When you have a flash, you'll notice that there is a definite feeling of landing, of being there. There is a kind of sudden nonlinear, out-of-the-blue landing fully on the ground. When that happens, there is an experience of stillness. You could be watching all sorts of things moving past, but the perceiver stays grounded, synchronized, still. That stillness comes from not projecting out. You just allow yourself to be on that dot, appreciating whatever you see.

The flash of perception is a simple moment, unburdened by any compulsion. In the next moment, we often feel the need to go further, to get more, to do something else. As photographers we will probably want to "capture the moment." If you give in to those compulsive feelings, the flash might last only an instant. If you are able to rest your mind and stay still, the experience will be more continuous. Either way, you will see that it is possible to let go of discursiveness, speed, and artistic ambition and simply meet the world as it is.

The Qualities of the Flash

It is helpful to look carefully at these moments when perception dawns out of nowhere. If you reflect on your visual experience, you will notice that the flash has certain qualities. As you develop familiarity with the qualities of the flash, it will become easier to distinguish genuine perceptions from similar experiences that are primarily conceptual.

The first characteristic of the flash is that perception arises all of a *sudden,* out of the blue. In the flow of ordinary activity—reading, talking, having lunch—there is an unexpected break. Suddenly something fresh occurs in a definite and unmistaken way. Perhaps the continuity of reading a menu and thinking about your lunch order collapses, and suddenly you see something. It could be a cube of ice in your water or a fly on the tablecloth. It could be anything. Preoccupation stops without warning. There is no gradual transition, only an abrupt discontinuity with the flow of mental activity preceding the moment of freshness.

Because the transition is sudden, it is also *shocking.* It comes as a bit of a jolt: you have been shaken out of vagueness and into the moment. It's a little like being startled by a loud noise or shocked by a spark of static electricity on a dry winter's day.

Because it is abrupt and disconnected from previous mental activity, the flash is subtly *disorienting.* The immediate perception is free from association or context. Usually our experience is embedded in a story line, which is itself taking place within the world of our projections. The flash of perception is free from both story line and reference point.

Sudden, shocking, and *disorienting* are all connected with dropping out of the conceptual realm and into the realm of direct experience. Without going through a reentry, you find yourself firmly on the earth—no longer in orbit—landed fully in the moment. These qualities highlight the contrast between these two realms.

Next are some qualities of the perceptual experience itself. Foremost among these qualities is *clarity:* a stainless, shining quality. Whatever you perceive is sharp and brilliant. It is unfiltered, definite, and precise. "Unfiltered" means that it is not overlain with labels or ideas. "Definite" means that you have no doubt about what you are perceiving, whether it is a patch of blue, sunlight, water, or a coffee cup. "Precise" means that all the details appear clearly, all at once.

Looking further, perception has the quality of *richness.* Because you are not diffused or scattered or moving, color and texture are seen with unusual intensity. They are penetrating in a very direct way, and you begin to resonate with them. It is as though you can feel the texture of form with your eyes.

When you rest in the present moment, completely with the perception, experience is one-pointed, stable, and free from distraction. There is stillness. There is no sense of separation between the perceiver and the perception. This is the quality of being *absorbed.*

Because perception is free from context, it floats in the present moment. This experience is *buoyant,* light, weightless. Self-centeredness and preoccupation have fallen away. You have connected with eye, mind, and heart, and the experience is joyful, relaxed, and liberating.

THE HUMAN CAMERA

The process of covering a fresh, unfiltered flash of perception with concepts happens quite quickly, often in a fraction of a second. In the first instant, there is the naked perception and basic form appears: color, light, texture, line, pattern, shape, space. In the next instant, you label what you have seen, categorize it, remember something similar, dredge up likes or dislikes, and so on.

One way to observe both the vividness of the flash and the way that vividness degenerates is by using the following exercise. We call it the Human Camera. You will soon understand why.

Put away your camera. You won't be taking any pictures. *You* will be the camera this time. In this exercise you are going to turn around with your eyes closed, suddenly open them like a shutter, and then close them again. This will expose the sensor of experience to the flash of perception. Whatever conceptual processing you do will become obvious in the moments following the flash.

You don't have to go anywhere special to do this exercise. Do it in your home or outside, as you prefer. Begin by standing in one place. Don't look for anything in particular. Just relax. Feel your feet on the ground. The earth is below and the sky is above. There is nothing special to see. Give up any expectations of seeing anything or having anything to photograph. Whether you are thinking or not thinking during this exercise is beside the point, so just relax.

When you feel settled, gently close your eyes and keep them closed. Slowly turn 180 degrees with your eyes shut, and then stand still. Notice sounds and bodily sensations. If you are outside, you might feel the breeze. Keep it simple.

After half a minute or so, open your eyes suddenly. Open them wide and let awareness meet whatever it meets. Notice what happens in the first instant, and then notice what happens after that. (It will all be over in a few seconds.) After a few more seconds close your eyes again, just as suddenly as you opened them before. The afterimage of what you saw will slowly dissolve. Relax your body and mind for a few moments, then with your eyes shut, turn another quarter turn. Look downward toward the ground. After half a minute or so, suddenly open your eyes again. Notice what happens. Then after a few more seconds, close your eyes again, turn another 180 degrees, tilt your head up, and do the whole thing again.

Continue like this for about five minutes, each time turning so that you don't know exactly what you will see when you open your eyes.

WHAT DID YOU EXPERIENCE?

When you are done, reflect on your experience. You can ask yourself the following questions:

- When you opened your eyes suddenly, what was seeing like?
- Was it very bright, almost overexposed for the first instants?
- Did you see space, form, shapes, colors, brightness, darkness?
- What happened in the next instant?
- Did you begin to label things—car, grass, yellow, person?
- Was it hard to come up with complete thoughts?

You might feel like walking around as you ponder these questions.

After a few minutes of contemplation, repeat the exercise. This time, gradually increase the speed: eyes closed for five seconds; eyes open for a second or two, noting your experience; eyes closed and turning in an unplanned direction; aim up, down, or straight ahead; eyes open again, noting your experience; and so on. Do this over and over.

If you find that you begin to label and describe while your eyes are open, increase your "shutter speed," opening and closing your eyes very quickly—perhaps opening your eyes for only a fraction of a second. This will short-circuit the thinking process. The more quickly you open and close your eyes, the less time there is for thinking to proliferate. You can experiment and find out what the best shutter speed is for you.

As you do this exercise, you will probably find that you have more and more vivid flashes of perception. You will probably also be shocked at how quickly visual experience dims when thinking mind kicks in. Most of the time, we tend to see the world through the filter of thinking mind. In contemplative photography we are trying to bias ourselves toward that first instant of seeing, when things are fresh and bright, and then staying with that freshness. Doing the human camera exercise will help you distinguish these two ways of seeing and gain confidence that perception—beyond conception—is continually available.

Here are some images that convey the freshness of the flash of perception.

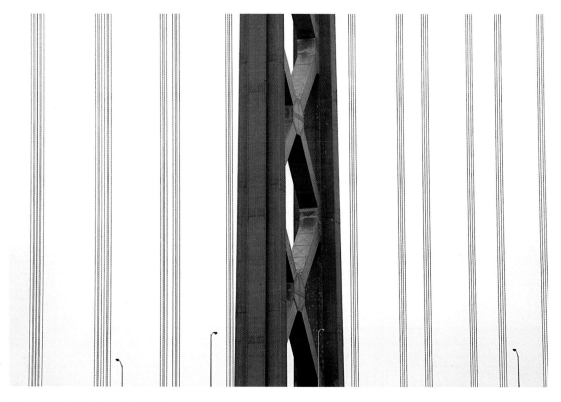

Michael Wood, San Francisco, 2006.

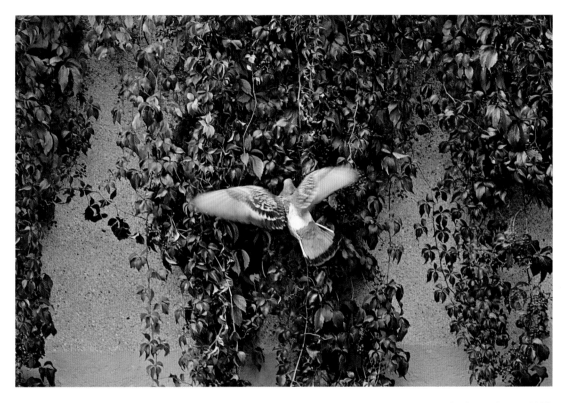

Michael Wood, Paris, 2009.

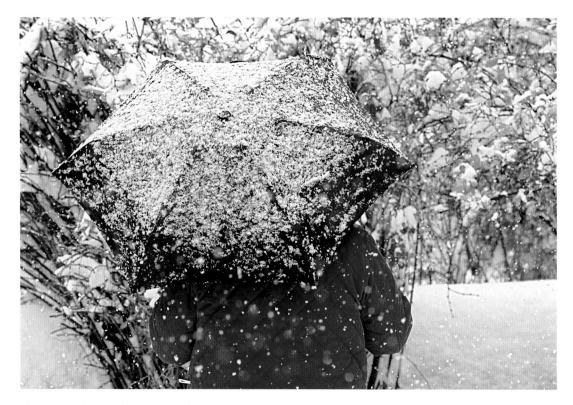

Michael Wood, Taos, 2007.

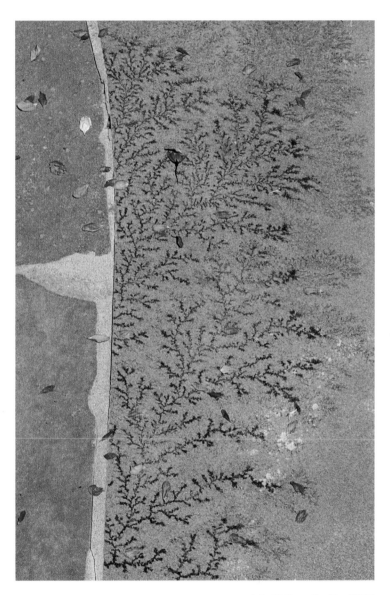

Julie DuBose, Boulder, 2007.

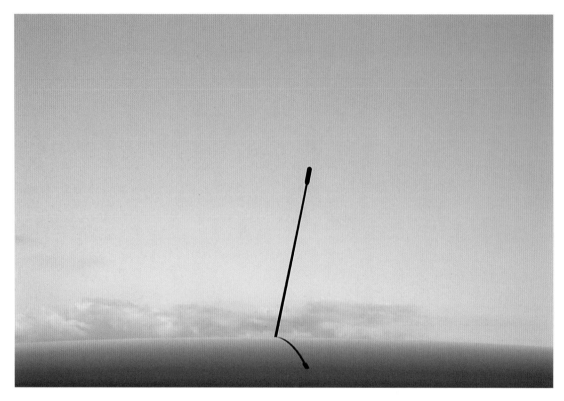

Nina Maria Mudita, Edinburgh, 2007.

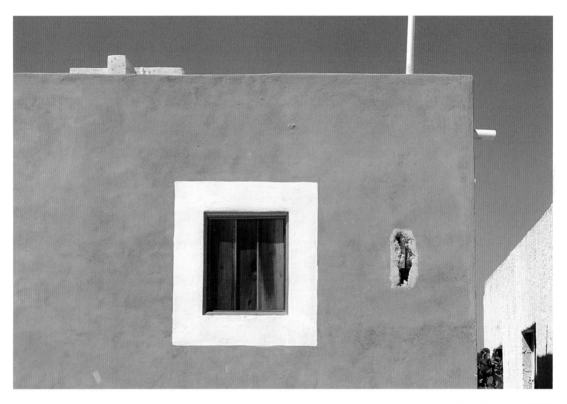

Andy Karr, Chuburna, 2009.

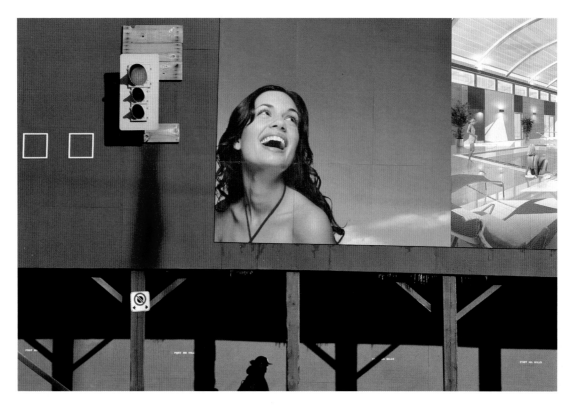

Sarah Jane Richards, Toronto, 2006.

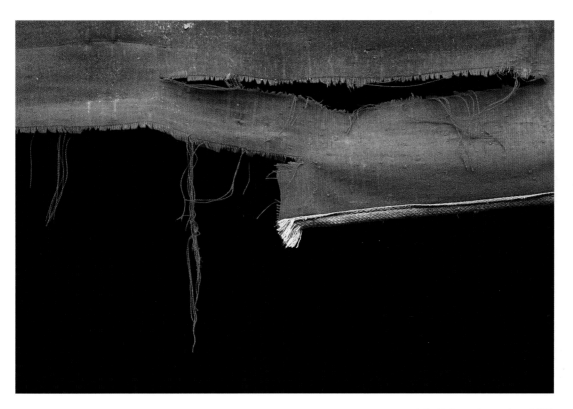

Julie DuBose, Amsterdam, 2009.

Michael Wood, Tucson, 2005.

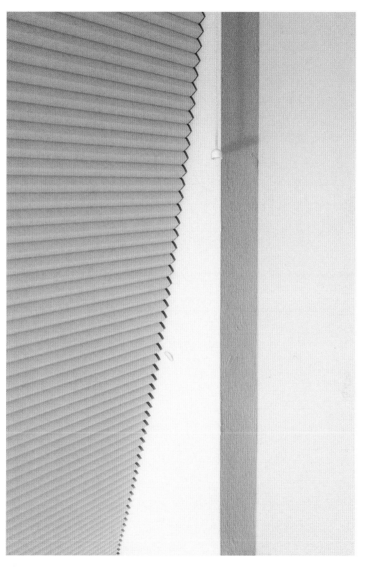

Todd Roseman, Louisville, 2010.

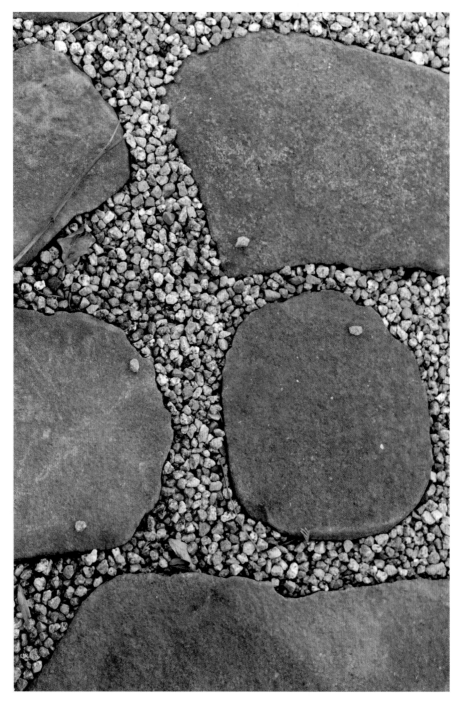

Andy Karr, Granville Ferry, 2009.

9

EXPLORING TEXTURE

In this assignment we are going to explore texture. Texture, like color, has no meaning. It is easy to recognize but difficult for the thinking mind to apply concepts to. Beyond "smooth" and "rough," we don't have many ideas about texture. This makes it a good intention to work with as we continue to investigate the flash of perception.

TEXTURE ASSIGNMENT

The texture assignment is slightly different from the color assignment. In the color assignment your intention is to see vivid, bold colors. With this intention, the experience of the flash tends to be intense and sudden. You might be going along without seeing much and then get zapped by a bright color that stops you in your tracks. The flash of perception is sudden and unexpected. There is a contrast between seeing and not seeing that is hard to miss. Mind and eye are brought together on the spot by the vivid experience of yellow, blue, or green.

Texture is everywhere, but it is less prominent than color. When you connect with it, you can develop a more continuous experience of perception. Walking down the street, you can feel texture everywhere: from the roughness of a raw concrete wall, to the smoothness of a car's chrome trim, to the bumpiness of a maple tree's bark, to the softness of a young child's skin.

The experiences of texture and color are both penetrating, yet the two experiences are different. The perception of texture seems to be gentler, deeper, and more "full-bodied." Seeing texture has an almost tactile quality, which can help you connect deeply with form. As you move through the world, you can feel your way as you look. Take your

time when you are practicing this assignment so that you thoroughly connect with the forms you come across. Moving slowly and connecting deeply, try to understand just what aspect of texture stops you.

When you are doing this assignment, notice how the quality of light affects your perception of texture. Rough surfaces will look one way on an overcast day; another on a bright, sunny day; and another in twilight. When an object is lit strongly from the side, the sharply contrasting brightness and shadow will give it more depth and dimension. When the light is indirect, the texture will be apparent but less pronounced. At twilight the texture will be muted.

As you do this assignment, it's important to look not for textured *things* but for the experience of texture itself. Whether it is rough or smooth—creases in soft leather or the sheen of satin—it should become tangible *visually*. Feel the surface with your eye, mind, and gut. If you try to shoot textured things, you might think, "Bark is rough and rocks are jagged. I should go looking for some bark and rocks to shoot." When you find bark and rocks, you could shoot them without actually experiencing their textures. You see them, and they confirm your preconceptions: "Yup, those things are pretty rough." Then you take some pictures without really seeing anything. That would defeat the purpose of the assignment.

GUIDELINES FOR THE TEXTURE ASSIGNMENT

Here are a few practical instructions for working with the texture assignment.

Establish a firm intention just to look for texture. Drop the intention to look for color (at least for the time being). This is like tuning your television to a different station; in this case, the texture channel.

Walk very slowly. Don't race to see how many images you can make. Take time to connect with the endless details of the surfaces around you.

When you take photographs of texture, fill the viewfinder or LCD with just the textured element that stopped you—nothing added and nothing missing. For example, if you take a photograph of the working end of a dust mop leaning against a wall, the viewer will likely see "a mop." If you move in to fill the frame with the texture of the mop head (using the macro setting if necessary), the viewer will experience your perception.

Sometimes you can pretend that your eyeballs have fingertips. When you see something, imagine you are also touching it. Let the sense of sight and touch come together. Try this for a little while without using your camera.

Another way to enhance your experience of texture is to try moving around your house with your eyes closed. Feel your way through that familiar environment. When

you feel something with vivid surface detail—either very rough or very smooth—open your eyes and look at it. Then close your eyes and continue your exploration.

Often when people do this assignment, they mistake visual patterns for texture. It is an easy mistake to make. For example, you could see a tightly woven piece of fabric with a small checkered design and think that you are experiencing the pattern as texture. Use your visual fingertips to make sure that the perception is really tactile, not just visual.

Here is a variety of images that should help you tune in to texture.

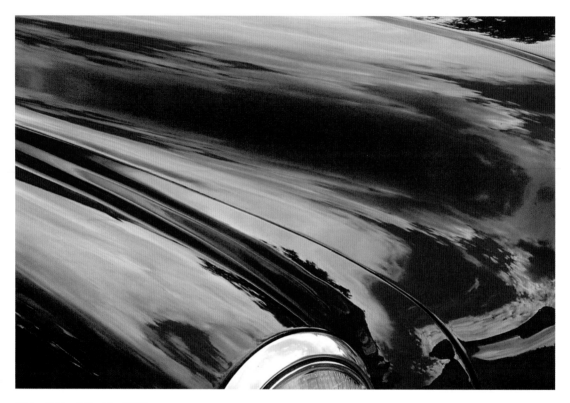

Michael Wood, Boulder, 2009.

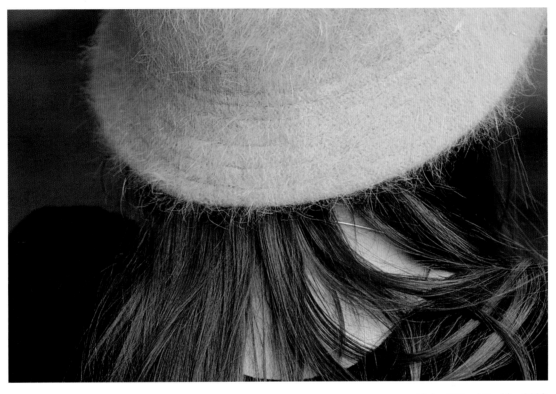

Michael Wood, Boulder, 2009.

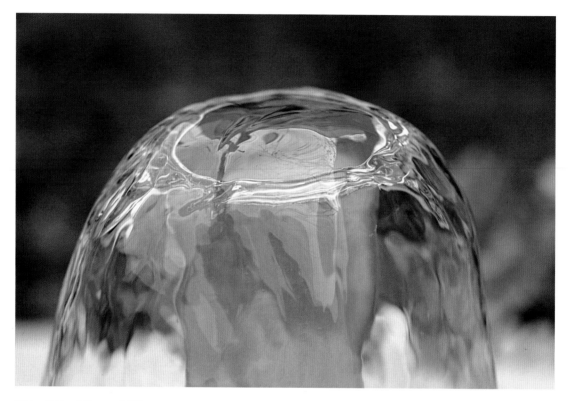

Michael Wood, Tucson, 2008.

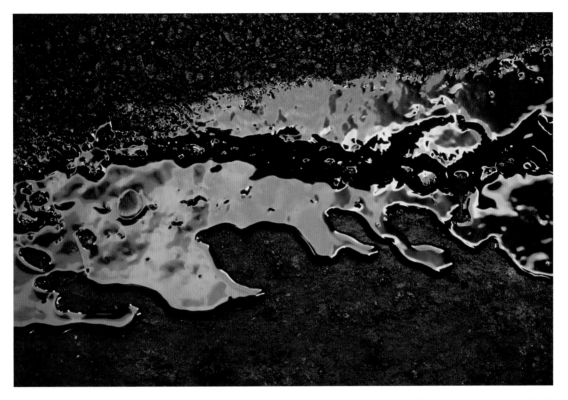

Michael Wood, New York, 2005.

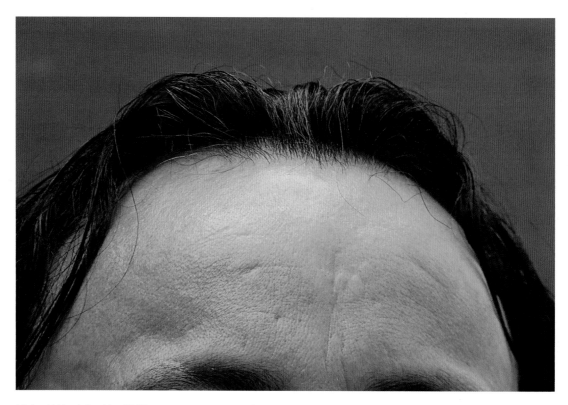

Michael Wood, Boulder, 2009.

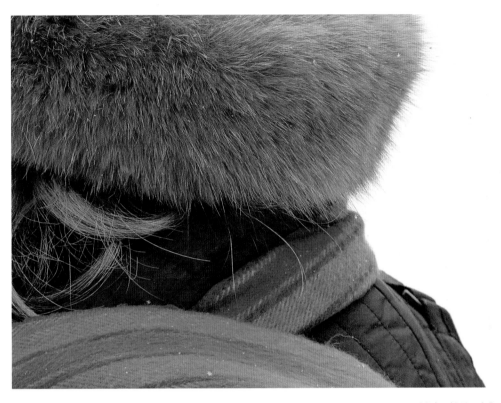

Michael Wood, Boulder, 2009.

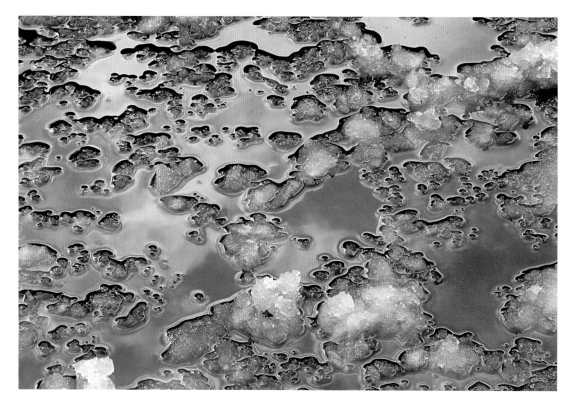

Michael Wood, Boulder, 2009.

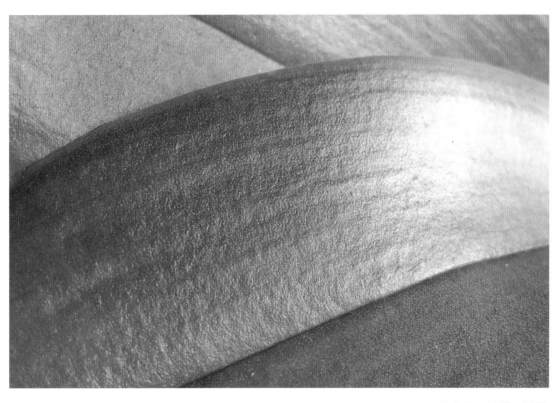

Andy Karr, Halifax, 2008.

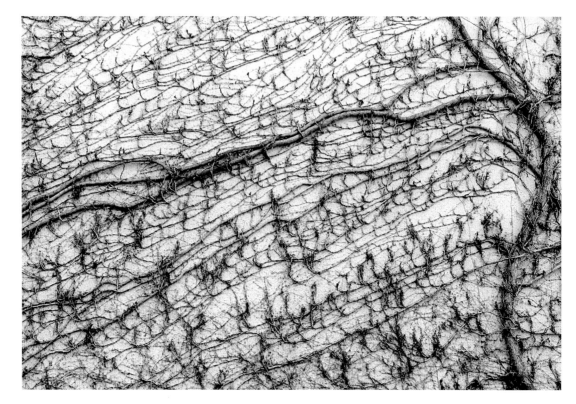

Andy Karr, Seine-Port, 2005.

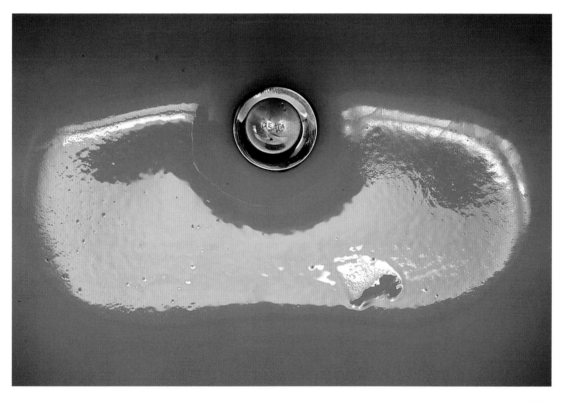

Todd Roseman, Louisville, 2010.

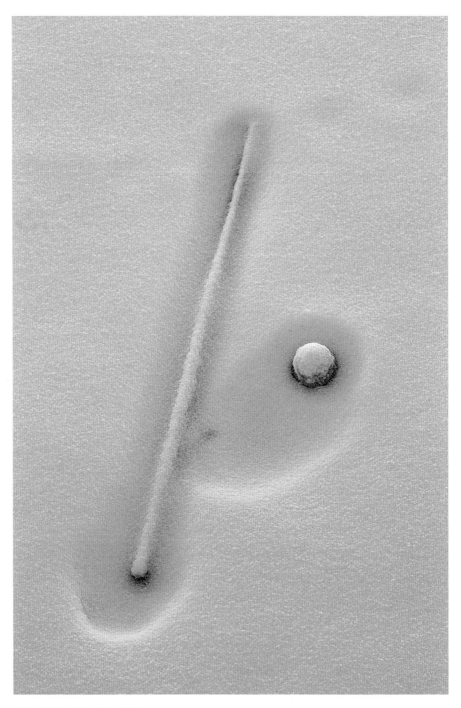

Michael Wood, Boulder, 2010.

10

DISCERNMENT

Maintaining the continuity of the contemplative state of mind, from the flash of perception through forming the equivalent, is vitally important to this practice, but it is not easy. In one moment you see clearly. In the next, thoughts erupt and you lose track of what you saw. Trying to form the equivalent of a perception that is no longer present is guesswork. On the other hand, if you can sustain the stability and insight of contemplative mind, it is easy to distinguish the characteristics of the perception and know just how to make the photograph—you won't be standing there with your camera in your hands, trying to figure out whether to shoot a vertical or a horizontal image. That's why visual discernment, the second part of the contemplative photography practice, is necessary.

When a flash of perception dawns, you land fully in the present. If the flash resonates within you, you commit to making an image. The moment you commit to a perception, the impulse to reach for your camera will also arise. Resist that impulse: it is not yet time to take the photograph. It is time to look further. Looking further is the heart of visual discernment. It is not a new, separate process but continuous with the flash. If you keep your gun in its holster when you experience a flash, and rest in the contemplative state of mind, visual form will clarify itself and you will come to know the qualities of the perception, just as they are. This is not something you need to *do* or to figure out. You just allow space for it to unfold naturally. As you become familiar with this practice, you will develop confidence that the less you struggle, the more form will reveal itself to nonconceptual intelligence.

The key to maintaining the contemplative state of mind is recognizing the many impulses toward nonresting that come up. You could have an intense flash of perception

and the next moment start thinking about how amazing the flash was or how wonderful your photograph will be. This is not resting with the perception. Instead of looking further, you have moved further from looking. You might think you're still seeing the perception, but the seeing is gone and what remains in its place is mere thinking about what you saw.

When thoughts and impulses follow a flash, notice that you are thinking without making a big deal about it: simply note the thinking and let go. Don't follow your thoughts or seeing will be lost. You don't need to move around either. You have already seen from where you are standing. Don't try to find a better angle to shoot from. Relax and stay where you are. Whatever mental or physical impulses arise, let them go and be still.

There is an old expression that's a good analogy for the way letting go feels, which is *to put in the clutch*. If you know how to drive a car with a standard transmission, you will know exactly what this is like. The gears are disengaged and the car can coast. When you experience a flash of perception, don't step on the gas to try to get the shot; put in the clutch. If you slam on the brakes, that will also increase the mental turmoil. If you struggle with your mind or your body, that will make things more turbulent, and perception will be lost. Instead, let go and relax. Once you let go of impulses to think and act, you can begin to settle body and mind and look further.

(This clutch business really dates us. You might have no idea what we are talking about. Most cars have automatic transmissions these days, and many people don't even learn to drive. Maybe a better contemporary image is to stop pedaling on your bicycle and coast.)

Looking Further

Sometimes when you are shooting, you will be stopped in your tracks by perceptions that completely interrupt the flow of mental activity, and you will have no doubt about what the perceptions are. At other times you might only notice the footprints of the flash: you know something happened in the visual realm, but what exactly the perception was eludes you. (It was more like a hiccup in the flow rather than a full-blown interruption.)

Whether the flash is obvious or obscure, begin the process of discernment by putting in the clutch. If the perception is vague, you can ask yourself, "What stopped me?" Don't look for a verbal answer to this question—look for a visual answer. You will probably be able to recognize the perception through seeing it anew.

When you are perceiving clearly, continue to look at what you see in a relaxed way.

As you look, be curious about the nature of that perception. What are its qualities? Generally, each perception has a dominant quality. It could be color or texture or light or shadow or space. It could be a mixture of these, or something else, but one quality will probably be the principal element that stopped you. Recognize what that is. You might find that it's the orange of some cushions—it's not the white surrounding them or the light falling across them or the texture of the material—it's just the color orange. Make that determination. At this point you should still be experiencing the perception. Examine where the boundaries of the perception are, where it visually ends and begins. Just how much is included? How much of the space around the principal element is integral to what you see? Is the shape of the perception horizontal or vertical? You are looking into three-dimensional space: is the background part of the perception, and if it is, is the whole scene sharp, or only part of it?

While you will need to use words to ask yourself these questions, you don't need to think of labels for what you see. Try to recognize the answers nonconceptually. Eventually, as you become familiar with this process, you will be able to do the investigation without verbalizing the questions.

LOOKING DEEPLY

Practicing visual discernment means looking deeply at what you see to discover the subtleties of perception. Through resting your body and mind, and staying with the perception in an inquisitive way, you discern exactly what you are seeing before you raise your camera. The process of looking can be quite extended. Here is a guided investigation that will help you understand how looking deeply can unfold. Try this practice inside, in a furnished room, with at least one window. You can do it sitting in a chair or standing in a comfortable, relaxed way. You won't need your camera.

Begin by gazing around the room. We use the word *gazing* here to indicate something a little different from normal looking, something more relaxed and receptive, with no intention of seeing anything in particular. It is not staring, which is a dull, fixed way of looking that might not see much of anything.

Gaze at the wall in front of you. It might feel like the wall is coming to you. Notice the wall's color. Is it white, off-white, or some other color? Does the paint have any texture, or is it very smooth? Are there patches of light or shadows on the wall? How does the color of the wall change in those areas?

Let your gaze drift up to the ceiling. Notice where the ceiling meets the wall. Is the line where they meet crisp or soft? Is the ceiling a different color or tone from the wall? Does it have a different texture?

Slowly move your gaze down to the floor. What is the flooring material like? What sort of grain or texture and color does it have? Notice that when you look at the floor, the ceiling is gone. The wall may no longer be in your visual field, but if it is visible in the periphery, notice that it appears to be vague and indistinct.

Move your gaze to the top of a table, desk, or other piece of furniture. Does that surface feel smooth to the eye? Are there any reflections in the surface, either clear or diffuse? Do you see the surface and the reflections at the same time, or is it one or the other? Can you look back and forth between the two? How do the qualities of that surface differ from the wall you looked at previously? Can you look at both the wall and the surface at the same time and feel the differences in their textures and colors?

Look at another piece of furniture. Can you visually feel its depth and weight, its dimensionality and spatial relationship to the nearest wall? Notice the shadows created by that piece of furniture.

Look at the window. Does it have a screen? How does the screen's texture feel visually? Look outside and gaze deeply. Look at the sky if it is visible. Is it pale blue or a deep, rich blue? Does the color change in different parts of the sky? If you see clouds, examine their qualities. Are they sharp and well defined, fluffy with soft edges, dark and heavy, even and dull? Are they moving quickly or are they still?

What is the light like outside? Is it very bright and a little hard to look at, or is it soft and flat? Are there shadows? Are the shadows completely black, or can you see objects within them? What color are the shadows: black, gray, blue?

Look deeply at a tree, building, or other large object. Do you see just the object alone or what is behind it as well? If you can shift your awareness between the object and its background, do that again and again. When you see the background, what is your perception of the object? Is it still the main object of perception or has it diminished? When you look directly at the object, what do you notice of the background?

Examine the qualities of the object in detail. Look at each of its parts. Is any part of it translucent, with light filtering through? Are there parts in shadow that look darker? What colors can you see? Look at the way each part is shaped. Are some parts heavy and others lighter? If you can see where the object joins the ground, what does that look like? What about where the object meets the sky?

This is the type of extensive investigation that brings out the subtleties of perception. It is looking further and further at the visual qualities of the world. Discernment begins with resting body and mind and continues with looking deeply. To look deeply, you need to do it in a way that is not too tight and not too loose. If you make too much effort, looking will be hard to sustain. Your eyes will quickly become numb, and it will be

hard to see. On the other hand, if you don't make enough effort, you will soon get distracted and thoughts will proliferate.

Learn to apply effort to discernment like a skillful violinist tuning his instrument: not too tight and not too loose.

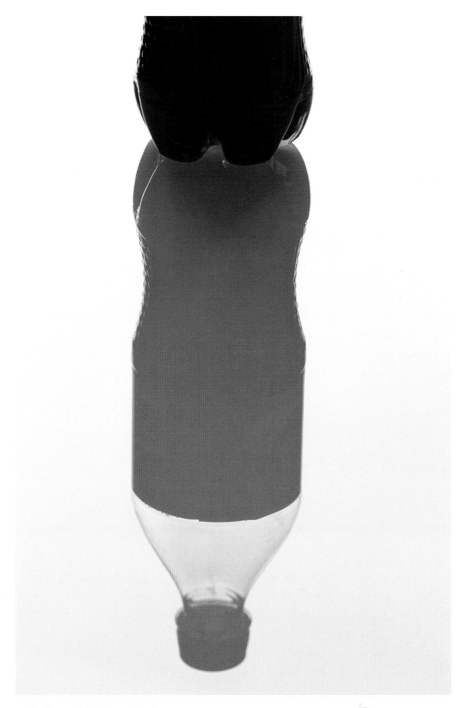

Michael Wood, Las Vegas, 2009.

11

SIMPLICITY

Most of us struggle with a lot of complexity in our lives. We often recite the famous mantra, "So much to do, so little time." When we feel like this, doing one thing at a time seems like such a luxury. With this attitude, we can't experience the space around our activities, and we often feel pressured and burned-out.

There is a remedy for this. It is simplicity: doing one thing at a time. When you are overwhelmed by complexity, come back to the one thing you are doing. You can't really do more than one thing at a time in any event. No matter how fast your mind is racing, there is just this present moment. There *is* no other time. There is no other place to be. There is nothing else to be doing. Just this. When this one thing is done, you will do the next thing, and that will be the only thing there is.

The past is only memory. The future has not been born: it is just imagination. Even this moment does not last. There is really nothing to cling to. Be simple. Your whole life is just this one dot.

Enjoy it!

SIMPLICITY ASSIGNMENT

The purpose of the simplicity assignment is to examine the relationship between form and space. Space intensifies the experience of form, and simple form intensifies the experience of space. In this assignment we are tuning in to the experience of form in space. Your intention should be to recognize perceptions where form and space produce strong contrasts—where the experience of the form is heightened because of the space around it.

Students often understand this assignment as shooting "sticks in the sky." They shoot pictures of telephone poles against the sky, bare trees against the sky, and chimneys against the sky, but this is a bit too literal. All of these subjects fit the description of "form and space," but the challenge with this assignment (as with all of these assignments) is to tune in to the *experience* of simplicity, not look for *things* that we think should fit that description.

Simplicity and space are aspects of our perception. Visual space can be produced by a red wall; a length of gray fabric; or a smooth, sandy beach. It can be produced by a backdrop of dark shadows, gray pavement, a tabletop, or a stretch of smooth concrete. Even the sky can create the experience of space—if we don't take it too literally. An object seen against any unadorned expanse will be surrounded by visual space.

Sometimes scenes of form in space will be two-dimensional; for example, a drop of ink on a sheet of paper, or a splash of color on a blank wall. Sometimes they will be three-dimensional, with one element standing out in a sparse environment; for example, a person standing in an empty courtyard or one bright flower surrounded by many leaves of the same type.

Images from this assignment might evoke Japanese aesthetics, which often feature spare and graceful objects against simple backgrounds that bring out rich textures and subtle colors: a Zen garden with a few large rocks in an expanse of neatly raked gravel or a large gold leafed screen ornamented with a painting of a single branch of cherry blossoms.

When you are doing this assignment, try to look at one thing at a time. Look at objects and also look at their environment. Don't hurry. Proceed in a relaxed way that allows you to see the space around things, not just the things themselves.

Here are some images where a variety of different environments create visual space. In each case there is a strong contrast between the relatively simple form and its environment. That creates the feeling of simplicity. The same objects could have been shot in other ways to express very different experiences.

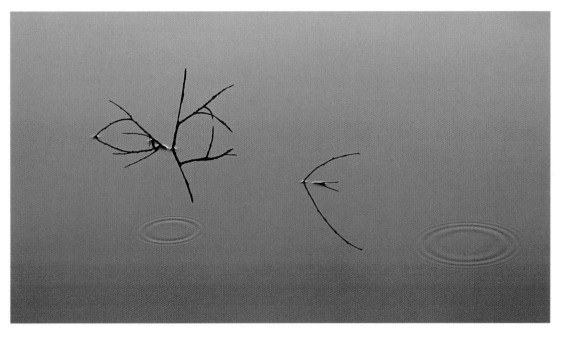

Michael Wood, Boulder, 2009.

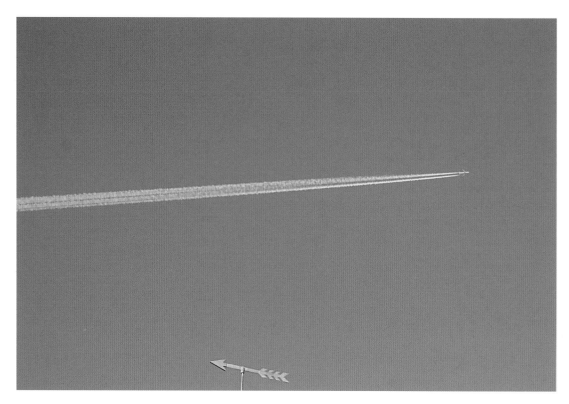

Michael Wood, Halifax, 2006.

130

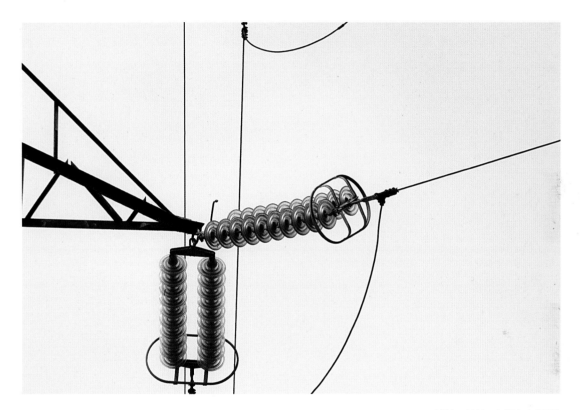

Michael Wood, Chiusi, 2006.

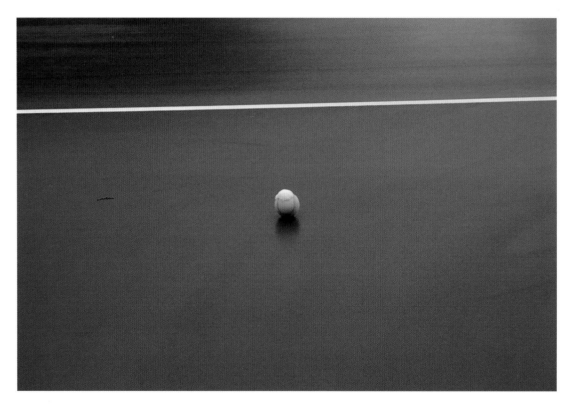

Michael Wood, Boulder, 2009.

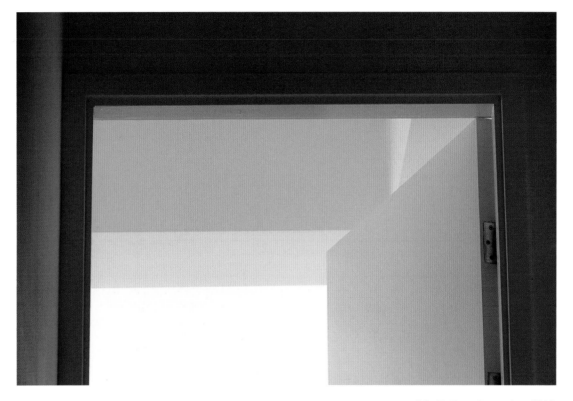

Julie DuBose, Amsterdam, 2009.

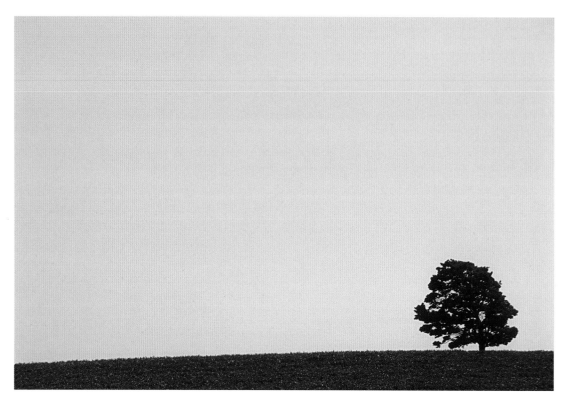

Michael Wood, Sussex, 1987.

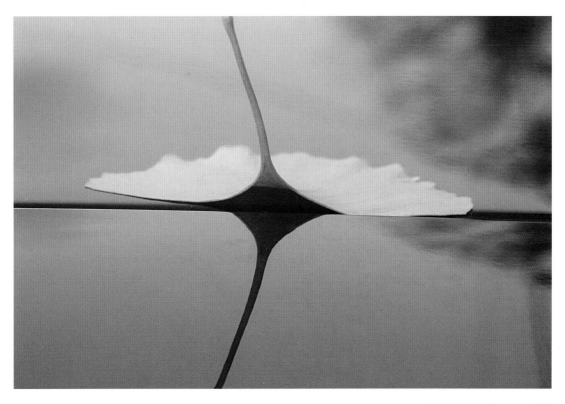

Sarah Wood, Toronto, 2007.

135

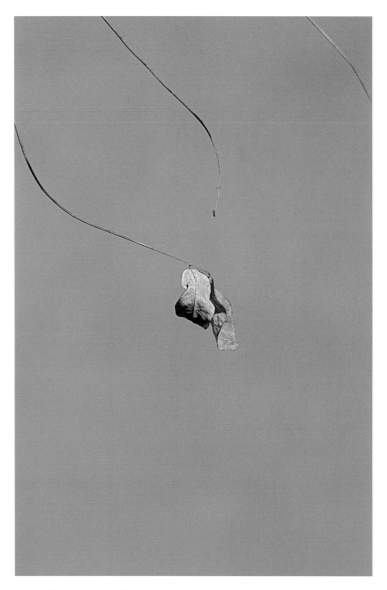

Michael Wood, Taos, 2007.

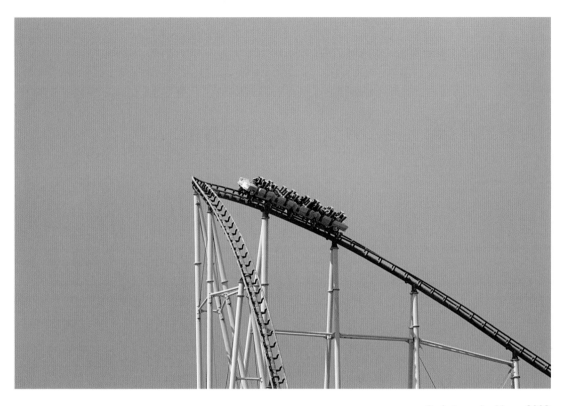

Paula Jones, Las Vegas, 2009.

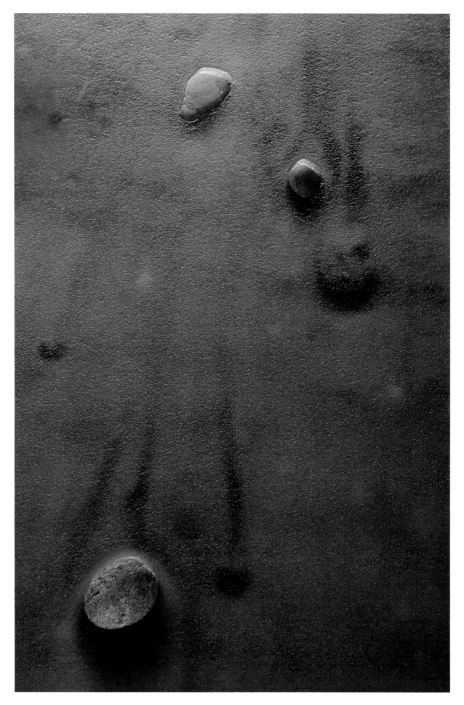

Michael Wood, Boulder, 2006.

12

JOINING MIND AND EYE

Looking and seeing are quite subtle activities, more so than you might imagine. We continually navigate a complex visual world, yet we are rarely conscious of everything that appears to our eyes. For example, you might wander into the kitchen with your eyes wide open, your visual field encompassing counters, sink, dishwasher, and cabinets. Upon entering the room, what you *see* is a glass of orange juice on the counter, even though most of the kitchen appears in your visual field. You see the glass of juice clearly, in a flash, and nothing else is part of that perception.

Visual Awareness

The meeting of mind and eye happens in different ways at different times. Much of the time, we are only aware of what is in the sweet spot in the center of our field of vision (the sweet spot corresponds to the fovea, a spot in the middle of the retina with the greatest acuity and the most sensitivity to color). Sometimes we are conscious of what appears to peripheral vision. Occasionally we are aware of the whole visual expanse. Awareness is a bit like a lens that zooms and pans around the visual field, yet awareness is insubstantial. It is not a material thing, which makes it hard to pin down. Nevertheless, there is nothing vague about awareness.

Knowing how awareness interacts with the eyes will sharpen your discernment by helping you identify the boundaries of your perceptions. When a perception appears just in the center of your visual field, you will know that. When it appears to the whole field, you will know that. Gaining facility with visual awareness will expand your ability

to see. You can learn to extend your awareness to see more. Here is an exercise that explores the way that awareness connects with the eyes. (This is similar to something we did in chapter 3.)

VISUAL AWARENESS EXERCISE

Begin by feeling the sensations of your eyes in their sockets. Take some time to settle into these feelings. Next look straight ahead in a relaxed way, without trying to see anything or identify anything. Look steadily in this one direction. Without moving your eyes, start to become aware of different parts of your visual field. Take your time. Begin with the upper part, then move to the right side, then the lower part, then the left side. Don't change your gaze while you are doing this. Keep looking straight ahead. Also try moving awareness up and down and from side to side. Still without changing your gaze, notice the different objects that appear in your field of view, one after another. When you have done this for a while, just be aware of the whole field at once, without fixating on anything at all.

In this exercise only your awareness should move. Notice that what you see changes, without your eyes moving or their focus varying. This is usually hard to observe because so many things are affecting vision at the same time: the head moves, the gaze shifts, the focus of the eyes changes, awareness moves about the visual field.

This exercise is not only good for investigating visual awareness; it is also a method you can use to relax your eyes and mind. When you are out shooting, and you start to feel speedy or frustrated, take a break and practice moving your awareness around your visual field. This should help settle your mind and loosen up your seeing.

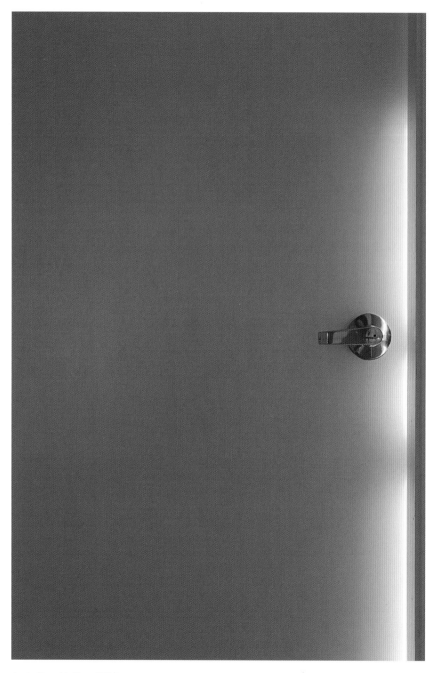

Andy Karr, Halifax, 2008.

13

FORMING THE EQUIVALENT I

It's only been a few years since we stopped shooting color slides, but it is already hard to remember what it was like to have to focus lenses manually, wind the film between shots, compensate exposures for scene brightness, change films for different lighting conditions, and wait hours or days to see how our shots came out. With a reasonable amount of light, most digital cameras produce excellent images with a minimum of manual intervention. Getting good results with film required a lot more technical expertise (and patience).

Some photographers bemoan the loss of the craft and aesthetics of film, but many appreciate how easy it is to produce sharp, well-exposed digital photographs. These changes in photographic technology allow the contemplative photographer to put more emphasis on seeing and less on technique. Much of the time you will be able to form the equivalent of your perceptions by simply pointing and shooting. By maintaining the contemplative state of mind, from the flash of perception through releasing the shutter, you will be able to express the brilliance of your perceptions without confusion or contrivance.

However, there are still good reasons to learn some basic photographic principles. If you understand what various camera settings and lens configurations can do, you will be able to form the equivalent of your perceptions confidently and accurately over a broad range of conditions. You will know the limitations of the medium and not be frustrated by trying to make images in unworkable situations. When the light or subject matter is challenging, you will know what manual adjustments will produce a faithful equivalent of what you see. When a shot doesn't work out, you will usually be able to figure out what went wrong and know how to take another (and when to walk away).

There is another important reason for learning the basics of photography: as you become familiar with these principles and the workings of your camera, your confidence in your abilities and your appreciation for your equipment will increase. The camera won't be just another mysterious digital device that defies comprehension. It will become a trusted creative tool.

Photographers use a rich technical vocabulary to discuss optics and camera systems. We will need to introduce a few of these terms to explain the basics. You may not be familiar with this terminology, but we hope that won't be too overwhelming. We will do our best to keep it simple. If you find it rough going, you might want to put these sections aside for a while and come back to them later.

Lenses

The camera's lens is the primary mechanism for forming an image. Some cameras have lenses that are permanently *fixed* to the camera body. Some have *interchangeable lenses* that can be removed and replaced with other lenses. Most compact cameras have fixed lenses. These lenses tend to be small and electronically operated. Digital single-lens reflex (DSLR or digital SLR) cameras have interchangeable lenses that offer more adaptability than fixed lenses. Cameras with interchangeable lenses can use a variety of lenses tailored to specific situations, such as shooting in low light, shooting close-ups, or shooting at great distances.

The choice of lens and its settings affects the camera's angle of view, perspective, focus, depth of field, and exposure. Each of these elements plays a role in creating images that are equivalents of your perceptions. The two main optical characteristics of lenses are their *focal length*[1] and their maximum *aperture*.[2]

Focal Length

Focal length is a measure of the lens's angle of view. The longer the focal length, the narrower the angle of view and the greater the magnification of the image. The shorter the focal length, the wider the angle of view and the less the image is magnified. Focal length is normally expressed in millimeters (mm).

Lenses are grouped into families according to their focal length. The main families are normal lenses, wide-angle lenses, and telephoto lenses. *Normal lenses*[3] have roughly the same perspective as the human eye. They are "normal" in the sense that they produce images that look natural to us—without any obvious perspective distortions—when viewed under normal conditions. They have angles of view between 45 and 55 degrees.

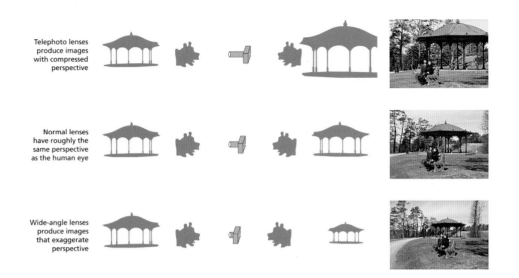

Telephoto lenses produce images with compressed perspective

Normal lenses have roughly the same perspective as the human eye

Wide-angle lenses produce images that exaggerate perspective

Wide-angle lenses produce images that exaggerate perspective, with objects appearing to be smaller and farther away than normal. These lenses have shorter focal lengths than normal lenses and viewing angles of 60 degrees or more. Very wide-angle lenses produce images that look quite distorted, as though space curved in at the edges.

Telephoto lenses produce images with compressed perspective. They make objects appear to be larger and closer than normal. These lenses have longer focal lengths than normal lenses and viewing angles of 40 degrees or less. Telephoto lenses produce perspective distortion that is the opposite of wide-angle lenses: space appears to be flattened by these lenses.

Some lenses have only one focal length. They are called *prime lenses* or *fixed focal length lenses*. *Zoom lenses* have variable focal lengths and angles of view. Some zoom lenses cover a range from wide-angle to telephoto. Others cover ranges that are just wide-angle or just telephoto.

Aperture

The *aperture* of a lens is the width of the physical opening in that lens. The maximum aperture of a lens determines how much light it can deliver to the sensor or film. This is often referred to as the speed of the lens: fast lenses deliver a lot of light, slower lenses deliver less light. Lens apertures are measured in *f-stops*.

F-stops are one of the more confusing bits of photographic terminology. For one thing, the numbers are counterintuitive. The smallest numbers are given to the largest

apertures (which let in the most light). The largest numbers are given to the smallest apertures (which let in the least light).

F-stops are also confusing because the numbers in the series do not form an easily recognizable pattern or progression. The standard series of whole, or full, f-stops is f/1, f/1.4, f/2, f/2.8, f/4, f/5.6, f/8, f/11, f/16, f/22, f/32, and so on.[4]

The numbers in this series are peculiar because they are not simply measurements of the size of the lens opening but ratios of the width of the opening to the focal length.[5] Despite their peculiar numerical values, the f-stop series is very easy to use (as we will see when we get into setting the exposure) because each of the apertures lets in twice as much light as the one after, and half as much as the one before. It is also very practical because the amount of light delivered by any lens at any particular f-stop value is the same as any other lens, regardless of the focal length of the lens: a telephoto lens set to f/5.6 and a wide-angle lens set to f/5.6 deliver the same amount of light to the camera's sensor or film despite their different angles of view.

Depth of Field

Another important characteristic of lenses is *depth of field*. Lenses focus precisely at only one distance at a time; however, when a lens is focused at a particular distance, there will be an area in front of and behind that plane that will also appear to be in focus. This

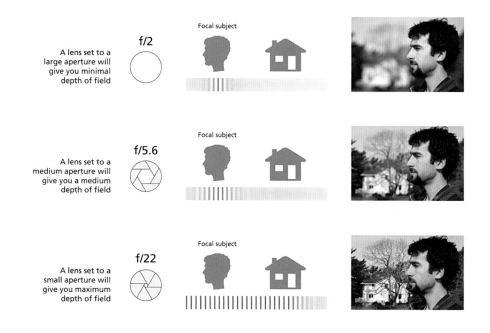

zone is called the depth of field. The zone can be quite large, encompassing everything from distant mountains to people standing only a few feet from the camera. It can be quite small, with just one flower in focus in a large field of blurred foliage. The depth of field is primarily determined by three factors: aperture, focal length, and distance from the lens. This is how it works:

- The smaller the aperture, the greater the depth of field
- The shorter the focal length, the greater the depth of field
- The farther the subject is from the lens, the greater the depth of field

Putting all of these together, a wide-angle lens set to a small aperture and placed a good distance from the subject will give you maximum depth of field. Conversely, a tele-photo lens set to a large aperture and placed close to the subject will give you minimal depth of field.

In Practice

That's a lot of technical information, and you might be wondering how it relates to the actual practice of contemplative photography. To put this in context, we will briefly review the main elements of the practice.

- The *first stage* of the practice is connecting with a flash of perception, a moment of clear seeing.
- When that perception resonates within you, eye, mind, and heart align on the same axis and you commit to making an image.
- Committing to the perception, you look further to discern its nature. This is the *second stage* of the practice.
- As you discern the nature of the perception, you begin to join discernment with your photographic knowledge.
- Finally you raise the camera to your eye, adjust the appropriate settings, and release the shutter to form the equivalent of the perception. This is the *third stage* of the practice.

The three stages of practice are continuous, bound together by an ongoing thread of perception. Technical understanding comes into play first during the stage of discernment, as you rest with the perception and recognize its characteristics. These characteristics will form the basis for the choices you make when you are forming the

equivalent. Technique comes to the fore during the third stage of the practice as you use your camera to make the image, choosing settings that express the qualities of the perception and your understanding of the medium.

Framing the Image

The first consideration in forming the equivalent is matching the framing of the image to the dimensions of your perception. Sometimes a perception will include just one visual element that occupies a small portion of your visual field. To form the equivalent of that perception, you isolate that element by choosing a lens with a narrow angle of view (using a telephoto lens or setting your zoom to a long focal length). If the perception has multiple elements and occupies a large portion of your visual field, you choose a lens with a wide angle of view (using a wide-angle lens or setting your zoom to a short focal length).

As you make choices about focal length, pay attention to the perspective of the image. Choosing too extreme a focal length will cause distortions (see above under Focal Length) that will make the image look unnatural and will not produce the equivalent of your perception. It is often better to use a moderate focal length and move the camera closer to the subject or farther away.

One way to avoid images with unnatural perspective is to shoot with a fixed focal length normal lens on a DSLR. (It can be quite pleasing to work within the constraints of such a simple setup.) You let your feet do the zooming, confident that your images will have a perspective that is the equivalent of your perception. (Fixed focal length lenses offer other benefits as well: they are usually faster, sharper, lighter, and cheaper than zoom lenses.)

Whatever lens you choose, make sure there is nothing extra and nothing missing when you frame the image. It is important to note that when we use the term *framing*, we are referring to the photographic technique. We are not talking about composition, which is making judgments about the arrangement of pictorial elements according to aesthetic rules or theories. Composition is *not* forming the equivalent of a perception. It is trying to improve upon the perception by manipulating the image.

Using Depth of Field

Another consideration in forming the equivalent is choosing a depth of field that expresses your perception. Generally you will want to use settings that give you the greatest depth of field so that your image is sharp throughout. This is particularly important

when you are very close to a subject, because the closer you are, the narrower the depth of field. You probably don't want to take a picture of someone's face with only the person's nose in focus! To increase depth of field, you choose a smaller aperture, a shorter focal length, shoot from farther away, or some combination of these.

Sometimes you will want to use a shallow depth of field to express your perception. If your perception is just one element in a complex environment, a shallow depth of field will help isolate what you see. A common example would be shooting a portrait where the perception is the person's face and not the background. You should be able to express that perception by using a longer focal length and a wide aperture. This will produce a sharp image of the person's face and blur the background and foreground. On the other hand, if the perception includes both the person and the environment, then you will want greater depth of field, so that both are in focus.

That's probably enough technical information for now. Try to work with it as you are shooting, particularly being aware of framing and depth of field. We will present more photographic principles and techniques in chapter 15.

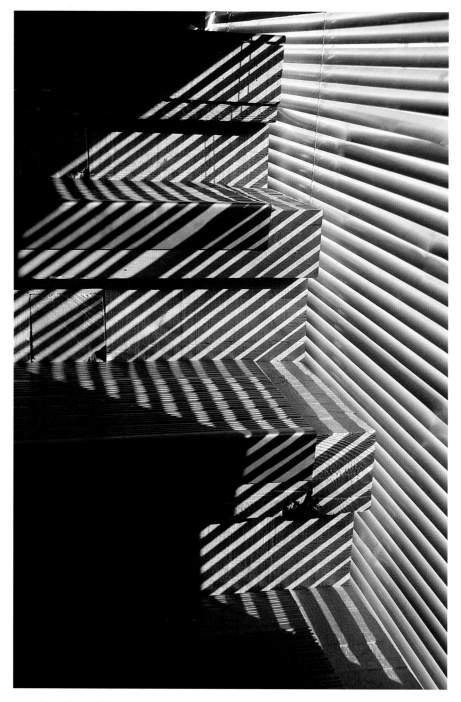

Anne Launcelott, Halifax, 2005.

14

WORKING WITH LIGHT

In the early morning on a clear day, long beams of orange sunlight will weave through the world. In the middle of the day, with the sun shining directly above you, forms will flatten out and be very bright. Late in the day, the light will again form angled shafts, flowing through the world with a soft reddish hue. As sunlight falls on structures and reflects off windows, it forms patterns of light, and these shapes move and change continually. These patterns are what we are going to shoot next.

LIGHT ASSIGNMENT

The intention for this assignment is to see patterns of light—not *things* that are illuminated, or shadows cast by objects that block the light. When you work on this assignment, don't try to be subtle. You will come across scenes where the lighting is dramatic or creates a glow or provides the basic ambience. There is nothing wrong with shooting fresh perceptions produced by these scenes. However, that is not what we are looking for in this assignment. Here we are looking for the patterns of light itself.

Both sunlight and artificial light produce radiant designs, but you will find it easier to work with strong, well-defined patterns of sunlight; it could be a shaft of light falling on the sidewalk in front of you or light coming through the window and falling on a table or a wall. It is just that simple. You can shoot this assignment both inside and outside: wherever you see pools or stripes or reflections of light. (Venetian blinds are a gift for this assignment.)

Paying attention to light is another way of staying in the moment, rooted in the actual experience of seeing things as they are. It is also a joy. The dance of sunlight has great power to cheer us up.

Here are some images of strong patterns of light.

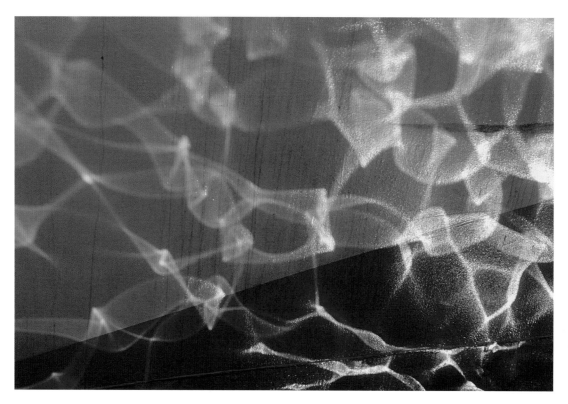

Michael Wood, Halifax, 2005.

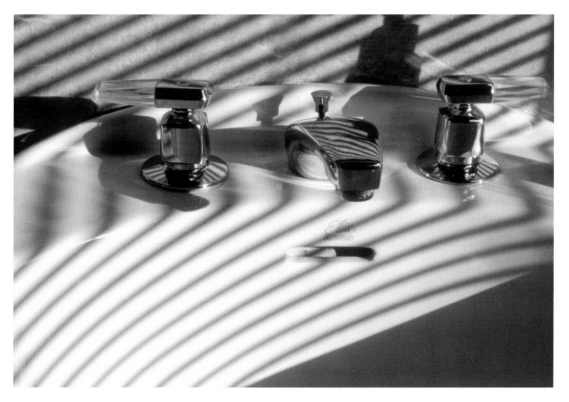

Andy Karr, Halifax, 2001.

153

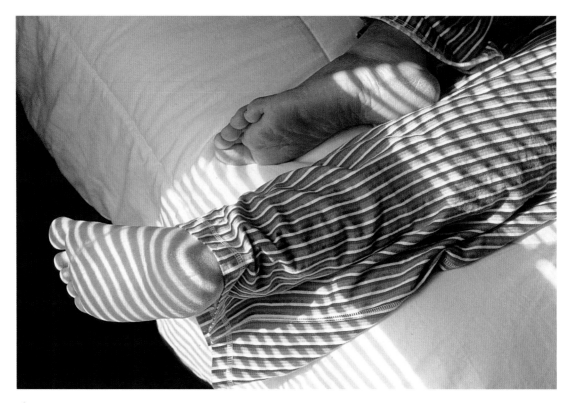

Michael Wood, Halifax, 2005.

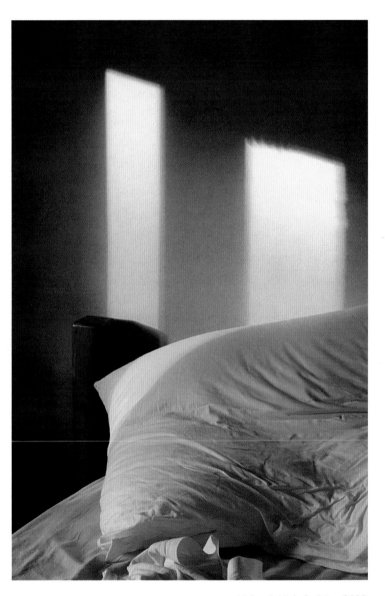

Helen A. Vink, St. Brice, 2008.

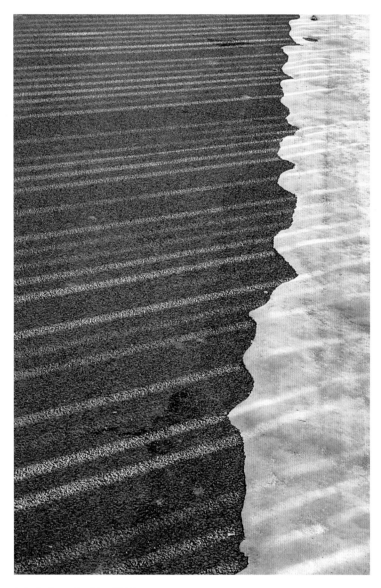

Julie DuBose, Boulder, 2009.

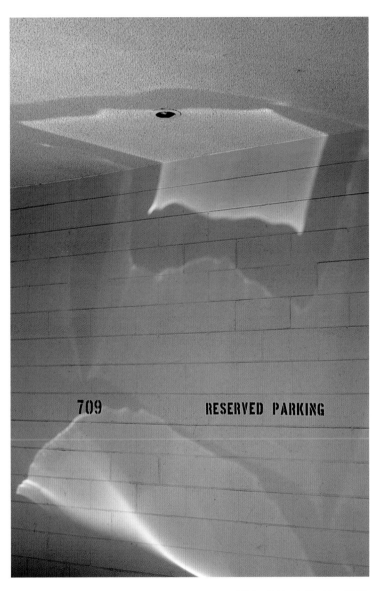

Michael Wood, Boulder, 2006.

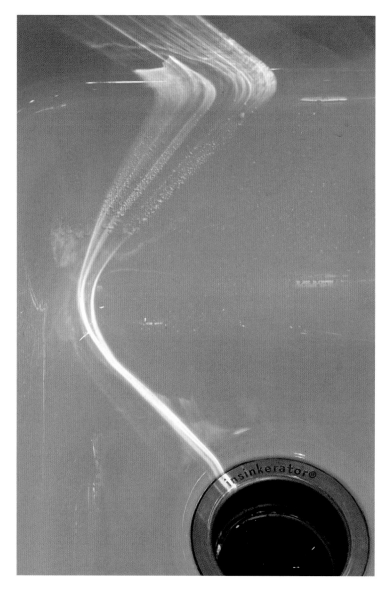

Michael Wood, Boulder, 2009.

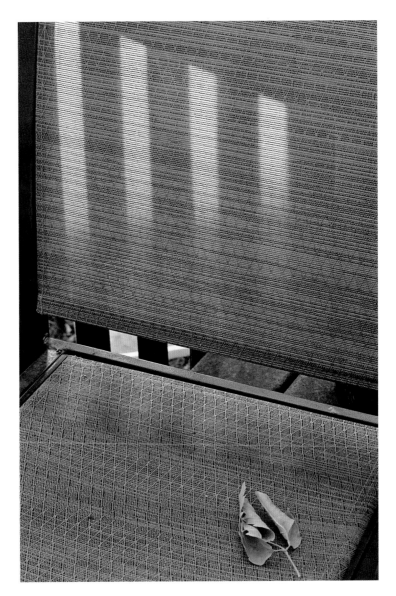

Michael Wood, Boulder, 2009.

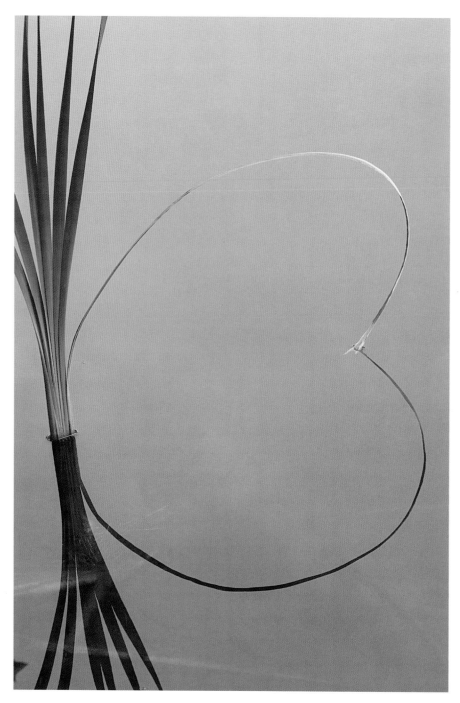

Michael Wood, Boise, 2006.

15

FORMING THE EQUIVALENT II

A picture that is overexposed or underexposed will not be the equivalent of your perception. Understanding the principles of exposure will help you make better images, even when the light is very bright or very dim.

Getting a good exposure means having the right *amount* of light on the camera's sensor: too much light and the image will be overexposed and washed out, too little light and it will be dark and murky. Controlling the amount of light to get the right exposure depends on three factors: the lens aperture, the shutter speed,[1] and the sensitivity of the sensor. Because these factors interact to produce the image, different combinations of settings can be used to produce the same exposure.

Shutter Speed

We have already discussed how aperture settings affect the amount of light reaching the sensor and how they affect depth of field. Fortunately, shutter speeds are simpler and more intuitive than f-stops. Shutter speeds are measured in seconds and fractions of seconds. The standard series of shutter speeds goes 30, 15, 8, 4, 2, 1, 1/2, 1/4, 1/8, 1/15, 1/30, 1/60, 1/125, 1/250, 1/500, 1/1000, and so on.[2] Slower speeds let in more light. Faster speeds let in less light. As with the series of f-stops, each setting lets in twice as much light as the one after, and half as much as the one before.

In addition to affecting the amount of light arriving at the sensor, shutter speed is important in other ways. At slow shutter speeds, camera shake can cause images to blur. (Longer focal lengths will magnify the effect of camera shake.) Moving subjects will also

blur at slow shutter speeds. Faster shutter speeds are useful for stopping camera shake and subject motion from affecting the image.

ISO Settings

Sensor sensitivity is straightforward. Sensors are made more sensitive by amplifying the signals they put out. Sensitivity is measured on a scale developed by the International Standards Organization (ISO), referred to simply as *ISO settings*. A typical series might go 100, 200, 400, 800, 1600, 3200. The higher the ISO number, the greater the sensitivity. Increasing the sensitivity of the sensor has the same effect on exposure as increasing the amount of light striking it. Each of the settings in this series is the equivalent of having half as much light as the one after, and twice as much as the one before.

Sensor sensitivity also affects the appearance of the image. Images produced at the lowest ISO setting usually have the least digital "noise," or "graininess." Noise increases as the sensor is made more sensitive. At high ISO settings, images can look quite speckled or grainy.

Exposure Combinations

To set the exposure, you work with the interactions between three factors. Because a full step either up or down in f-stop, shutter speed, or ISO doubles or halves the amount of light going into the image, if you change any one of these factors by one or more steps and you move one of the others the same number of steps in the opposite direction, the two changes will offset each other and produce the same exposure. This is a very useful equation.

When you are shooting outside on a bright summer's day, you will have lots of light to work with, and the f-stop/shutter speed/ISO equation will give you a great deal of flexibility in forming the equivalent. If you need great depth of field in an image, you should be able to shoot with a small lens aperture, fast shutter speed, and low ISO. If you need shallow depth of field, you will be able to open your lens wide, speed up the shutter (by the same number of steps as you opened the aperture), and keep the same ISO. In both cases you will have the same exposure, but by opening the lens aperture and increasing the shutter speed, you reduce the depth of field.

When you are shooting inside late in the day, your choices will be more constrained. You will need to open the aperture fairly wide, slow down the shutter, and crank up the ISO to get enough light to make a good exposure. You might be able to adjust the depth of field a bit, but your choice of shutter speed will be limited by camera shake and subject

blur, and your choice of ISO will be limited by image noise. When you know the way these factors interact, you can choose which limit to push so that you get the best equivalent of your perception and a well-exposed image.

White Balance

There is one more topic we should touch on before finishing this technical discussion: setting the *white balance* (sometimes referred to as *color balance*). White balance affects the way color data from the camera's sensor is interpreted when an image is displayed on screen or printed.

Different light sources produce different qualities of light. These range from the warm light of candle flames, sunrises, sunsets, and tungsten lightbulbs through the neutral light of the midday sun in a cloudless sky to the cool light of overcast skies or shade.

The human eye and brain are adept at compensating for different qualities of light; a white piece of paper will look white under many different lighting conditions. Digital cameras have more difficulty with this task and sometimes need your guidance to know how things are supposed to look. Incorrect white balance settings give images an unnatural color cast. The color cast can be corrected on a computer, but it is generally better to get the white balance right at the time of making the image.

There are different ways to adjust white balance. All digital cameras have an automatic setting that estimates the best white balance, based on the overall color distribution in a scene. This system is most effective in daylight scenes where there is at least one white or neutral element.

Most cameras also have several white balance presets that are useful for situations where the automatic setting does not produce accurate results. Typically, these include settings for tungsten light, florescent light, electronic flash, and shade.

Some cameras allow you to create custom white balance settings using a neutral reference such as a gray card or a white piece of paper. You do this by placing the reference so that it reflects the same light as the scene you are photographing and indicating to the camera, "This is white."

Going Beyond Auto

The automatic metering systems in most digital cameras do excellent jobs of adjusting exposure and white balance over a broad range of lighting conditions, but they do have limitations. Environments dominated by relatively bright elements (such as snow or backlighting) and very dark scenes with low contrast (such as dark subjects against dark

backgrounds) may produce bad exposures. Scenes lit by artificial light, particularly mixtures of different kinds of illumination, may produce poor color balance. In these situations you will need some manual interventions to get a good image.

We can't tell you exactly how to make these adjustments with your particular camera. For one thing, there are so many different models, each with its own menu systems and ways of adjusting settings. For another, each camera usually has more than one way of accomplishing a particular task. You will need to see which methods are available on your camera. Unfortunately you will probably have to read the manual to do this (a task few of us relish) and experiment with some of the different techniques.

At first, going beyond the automatic settings can be daunting. The counterpart of the sophistication and versatility of modern digital cameras is that their controls and menus are often complex and difficult to understand. Also, most camera manuals are long on detail, and short on explanation. They tell you a lot about the adjustments you can make but not much about why you might want to make them. We hope that, armed with this understanding of basic photographic principles, you will have enough context to be able to see the significance of menu items and settings that would otherwise be obscure.

Fortunately, photography is not computer science. There are not too many techniques you need to understand to make images that are good equivalents of your perceptions. It is worthwhile spending some time learning the principles we have covered and applying them when you shoot.

Michael Wood, Toronto, 2006.

16

SEEING SPACE

The simplicity assignment explores the relationship between form and space, emphasizing form. The space assignment continues this exploration, but this time the emphasis is on space. (Again, it is important to bear in mind that we are describing aspects of perception rather than subject matter.)

When you look at a clear sky, you could think, "That's just space; there's nothing there." This describes a kind of dead emptiness, not the vibrant quality of visual space. Rather than the vacant quality of a clear sky or a blank wall, visual space creates dynamic tension between elements in a photograph. It introduces a subtle sensation of movement the viewer can feel. Becoming familiar with this experience of space will also help you make images of scenes that are filled with objects and activity.

By its very nature, space is the most nonconceptual photographic intention we can work with because it is difficult to solidify or overlay with ideas or associations. In the simplicity assignment, objects of perception are seen precisely and clearly because space surrounds them. We can easily express these perceptions. Form and space have an intimate relationship: space intensifies the clarity of form, and form creates boundaries that bring out visual space.

SPACE ASSIGNMENT

The challenge in the space assignment is to shift your intention from seeing forms in space to seeing space itself—space that surrounds things and space that is between things. Usually we notice only the objects in space. What lies between them is a visual black hole. If you want to see this in action, try to slowly scan your current environment, using

your eyes like a flashlight beam. Scan 180 degrees of space with your visual beam. Start by looking directly to one side, and then move the beam gradually all the way around to the other. You will probably find it extremely difficult to look at each surface your vision passes over without jumping from object to object; it is not surprising that people don't take many photographs that express the quality of space.

Visual space can affect you in a variety of ways. Sometimes it can feel very two-dimensional, like the space between two large rocks. At other times it can feel more three-dimensional, with qualities of depth and openness you can sense and see. Sometimes space can feel flat, full, and tight. At other times it can be very relaxing. Space can be startling. We are so used to looking at things that to see the absence of things can throw us off balance. This can be unsettling and provocative. These are subtle perceptions, but once you open the door to them, the possibilities are endless.

Space is a new area for visual exploration ("Space: the final frontier. These are the voyages of the contemplative photographer . . ."). All perceptions appear in space, even color, texture, and light. To shift the allegiance of your eyes and mind from things to space, you need to relax your habits of nailing down objects of perception with concepts. You have to lighten up the process of looking to tune in to this less-tangible experience. To perceive space, put your clutch in fully to disengage the gears of conceptual mind. Become untethered so that vision can float and drift. See forms and objects as anchors for space. When you can see houses, lamps, and trees as frames and anchors, then space will begin to appear to you. When you manage to see objects as merely frames and anchors, space becomes the dominant visual element.

Space is an inherent part of our world. It is around us everywhere, all the time: in the foreground, in the background, in the distance, and close at hand. Everything we do from this point on in contemplative photography will be enhanced by connecting with the experience of visual space. This is a key aspect of fresh seeing. Seeing space creates a greater field in which flashes of perception can occur. By reducing fixation on objects, you can open your eyes more, your mind more, and go out farther and farther, feeling the spacious quality of the world. By doing so, you will be able to see so much more— including the dynamic ways people and objects play and interact—expressing their various natures in space.

The following images show how things that we don't normally associate with space can produce an experience of visual space.

Sarah Jane Richards, Hong Kong, 2007.

Michael Wood, Longmont, 2009.

Michael Wood, Boulder, 2008.

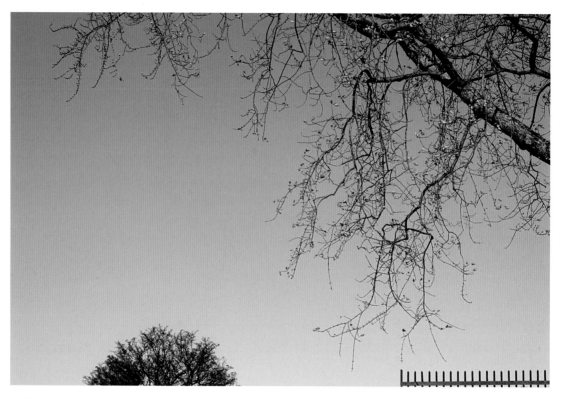

Michael Wood, Halifax, 2005.

172

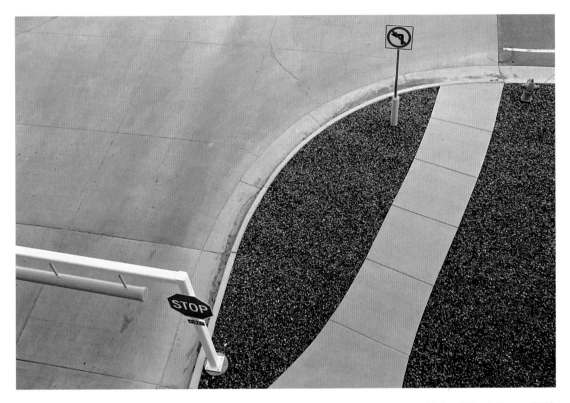

Michael Wood, Denver, 2009.

173

Andy Karr, Halifax, 2006.

174

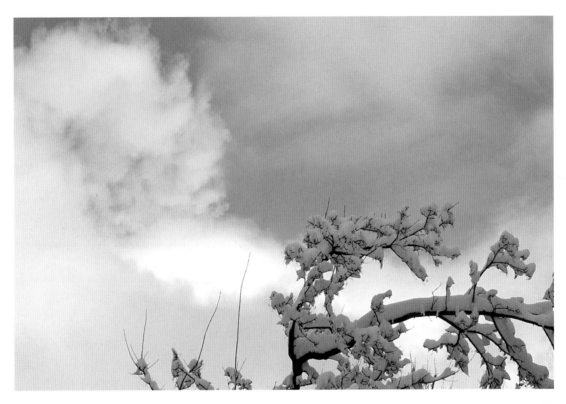

Michael Wood, Boulder, 2009.

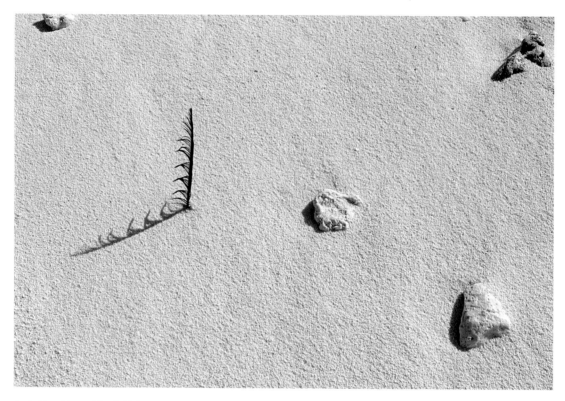

Andy Karr, Heron Island, 2005.

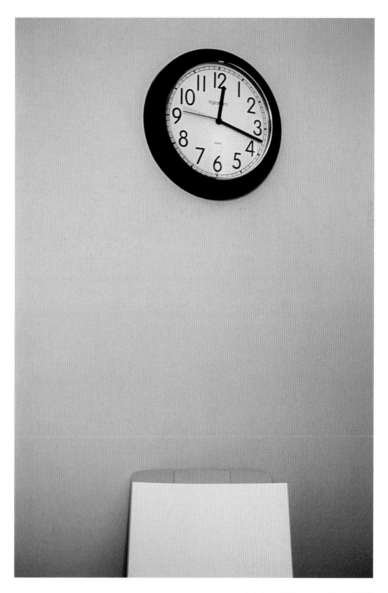

Michael Wood, Halifax, 1999.

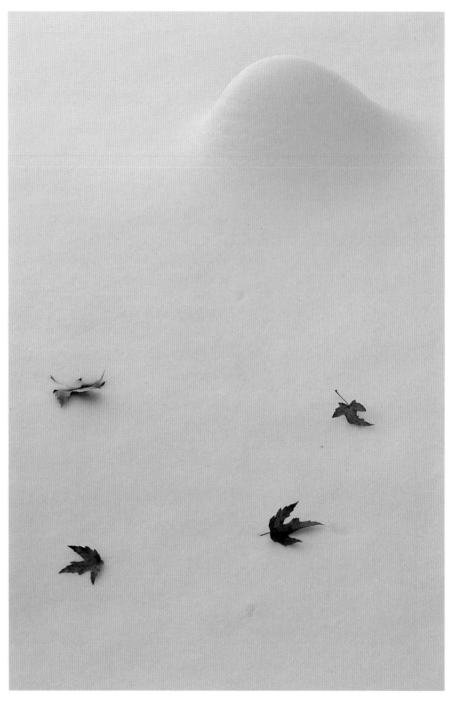

Michael Wood, Boulder, 2009.

17

EQUALITY

Looking through the images in this book, you might get the idea that there is such a thing as a contemplative photographic style, or that only certain subject matter is appropriate for the contemplative photographer. This is not the case: there is no such style and no such subject matter.

Contemplative photography is a method for training eye and mind, not a school of photography. We've chosen the images in this book to guide you in your practice, not to show you what types of pictures *you* should make. In choosing images we have tried to show how uncontrived seeing produces powerful, fresh photographs. We have also tried to point out the flash of perception and indicate the intentions for the different assignments.

This contemplative method is applicable to any subject matter and any form of creative photography. All subjects are equally capable of provoking fresh perception. It is not what you shoot but how you shoot it. If you rely on direct perception and nonconceptual intelligence, it will be contemplative photography. On the other hand, if you shoot color or texture from a conceptual perspective, it won't be contemplative photography at all; it will be conceptual. This distinction resides within your own mind, but—as we have seen—your images will express what that state of mind was.

If you would like to see examples of how others have applied this approach to diverse forms of photography, look at the exquisite landscapes of Weston, the fine architectural interiors of Kertész, or the brilliant portraits of Cartier-Bresson. Each of these photographers brought a fresh eye and an unfettered mind to subject matter that easily succumbs to the contrived and formulaic.

The value of this contemplative method is not limited to photography. It has much to offer for the rest of our lives. With or without the camera, the joy of seeing can be one

of life's treasures. When a perception dawns and you don't have a camera, or conditions are not right to make a picture, you don't need to feel frustration or regret. That's the time to realize how precious seeing itself is. That experience can be as rich as tasting the first few bites of a fine meal or hearing a lovely melodic line in a favorite piece of music. Enjoy it!

The way to cultivate and deepen the everyday experience of fresh seeing is by first having the clear intention to look. Try to periodically remind yourself of this intent. Next, recognize naturally occurring moments of seeing when they do arise. Don't pounce on them, just note their occurrence. Finally, don't cling tightly to these experiences when they do occur. Let them go without a second thought and open up to whatever comes next. If you practice in this way, more and more you will find that seeing comes to you.

The joy of the contemplative state of mind is another great treasure. The experience of openness and freedom from preoccupation is rich and blissful. It can arise at any time. When you find yourself free from hope and fear about the future, fixation and anxiety about the present, and nostalgia and regret about the past, the contemplative state of mind will be peace itself—spacious relaxation. Enjoy that! The contemplative mind is cultivated in the same way you cultivate uncontrived seeing: through intention, recognition, and not clinging.

Finally, there is one thing worth reflecting on that this practice only hints at: the remarkable difference between relating to the world directly and relating to our concepts, or our version, of the world. This suggests that we don't need to rely on our ideas about things to navigate our lives. Instead of depending on the usual "I like this, I don't like that"; "She is my friend and he is my enemy"; "This is good for me and this makes me unhappy," we can see things in their own light, as they actually are, and deal with them accordingly. We don't need to use all of these concepts to fend off the world's brilliance.

Seeing things as they are is also accepting them as they are, which leads to appreciating them as they are. This is the way to equanimity and a sane and meaningful life. We may not always be able to get what we want and avoid what we don't want, but by letting go of some of our ideas about these things, we can experience them fresh and lead a life with heart.

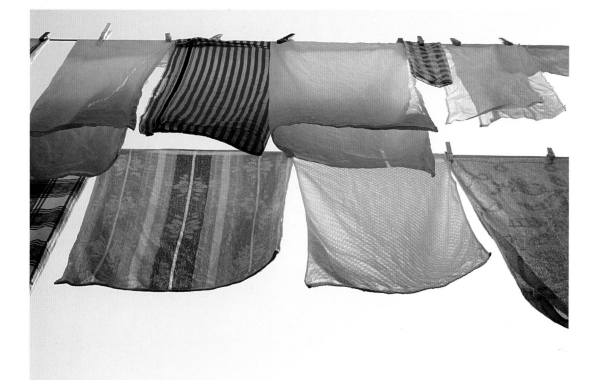

Michael Wood, Sienna, 2006.

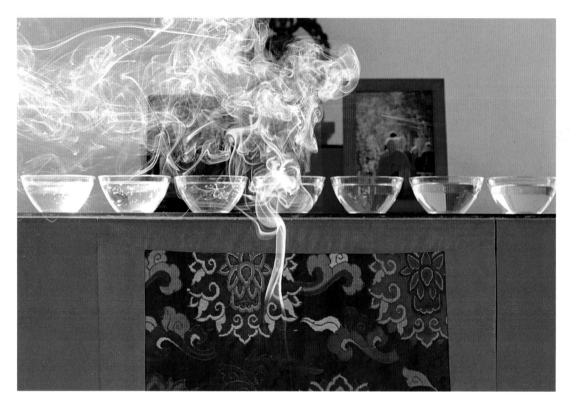

Andy Karr, Milk Lake, 2007.

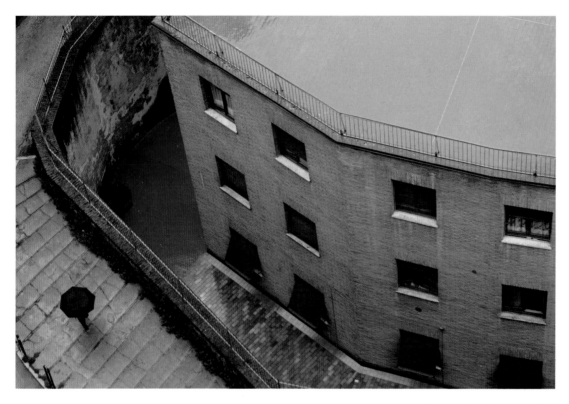

Michael Wood, Perugia, 2006.

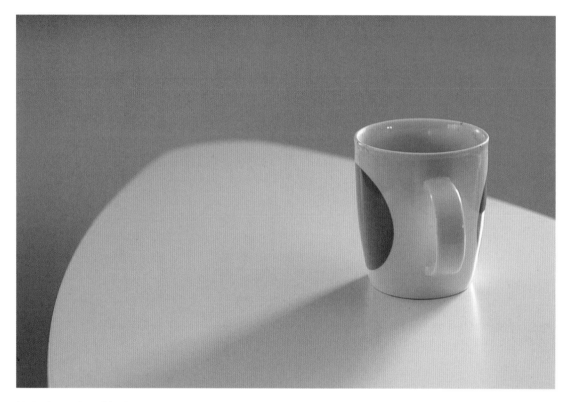

Michael Wood, Boulder, 2008.

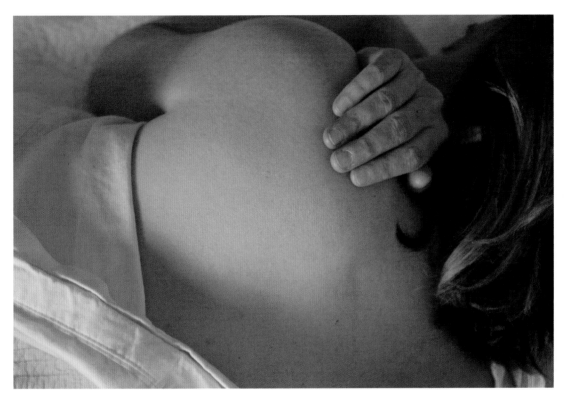

Michael Wood, Boulder, 2009.

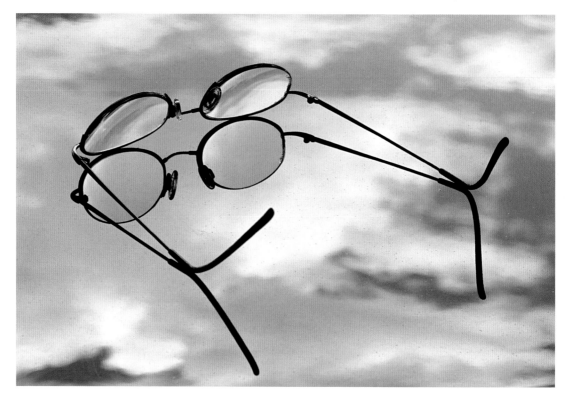

Michael Wood, Boulder, 2009.

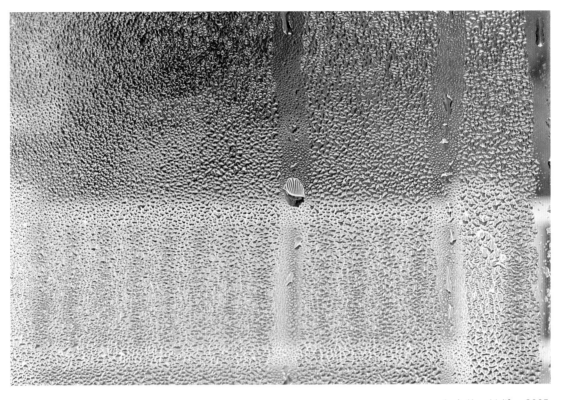

Andy Karr, Halifax, 2005.

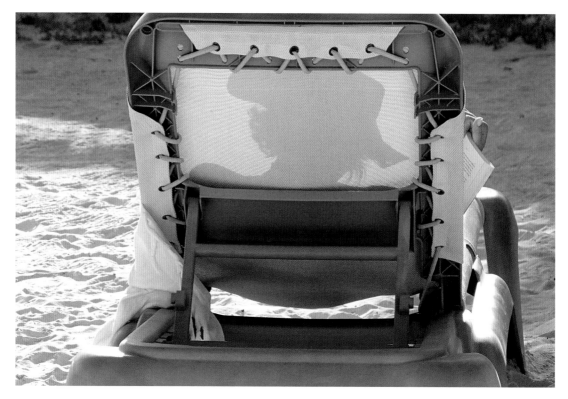

Andy Karr, Tulum, 2008.

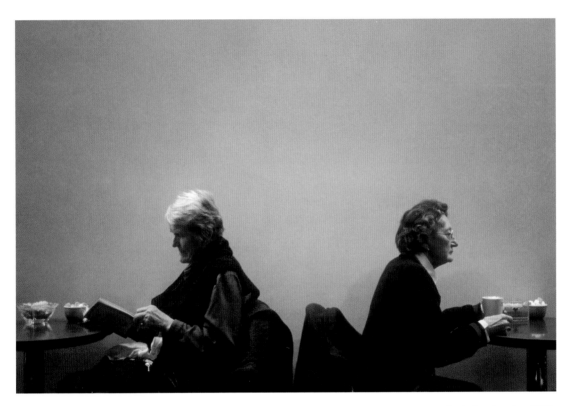

Andy Karr, London, 2001.

Andy Karr, New York, 2007.

Benjamin Wood, Chicago, 2005.

EPILOGUE

This book presents an approach to photography that is grounded in Buddhist teachings on perception, creativity, and wisdom. The connection between Buddhism and photography might not be obvious at first glance, but Buddhists have studied the mind and heart and applied their understanding and practices to the challenges of life for more than twenty-five hundred years. Buddhism also has rich traditions of expressing wisdom and realization through the arts. Finally, and perhaps most important, photography and Buddhism share essential interests: both are concerned with clear seeing.

Buddhism is concerned with clear seeing because clear seeing is the ultimate antidote for confusion and ignorance. Attaining liberation from confusion and ignorance is Buddhism's raison d'être. Clear seeing is a primary concern for the art of photography because clear seeing is the source of vivid, fresh images—photography's raison d'être.

The particular confluence between Buddhism and photography that led to this book began in the middle of the last century, when Chögyam Trungpa Rinpoche[1] got his first camera. At the age of two, Trungpa Rinpoche had been recognized as the eleventh incarnation of one of the highest lamas in eastern Tibet. As a child, he went through the rigorous traditional training that was typical for such an incarnation: extensive study of the Buddhist teachings and intensive practice of the stages of meditation.

Trungpa Rinpoche took his first photograph when he was fifteen, a portrait of his principal teacher on the roof of his monastery. Four years later, he fled his homeland to escape the Chinese takeover, leading a group of refugees across the Himalayas to safety in India.[2] He was twenty years old when he arrived, and India was modern compared with medieval Tibet. He spent the next few years exploring this new world. He continued to

take pictures during this period, mostly snapshots of Tibetan friends, traveling companions, and Buddhist sacred places in India.

In 1963 he traveled to England to study comparative religion and philosophy at Oxford University. He later wrote, "I had to immerse myself thoroughly in everything, from the doctrines of Western religion up to the way people tied their shoelaces."³ Intrigued by his exposure to Western and Japanese art, he began to explore ways the camera could be used to create images of the world of form: the naked appearance of things, before they are overlaid with any conceptions about what they mean or what they are.

After Oxford, Trungpa Rinpoche founded the first Tibetan Buddhist meditation center in the West in the rolling hills of Dumfriesshire, Scotland. Within a few years, he moved to America, attracted by the fertile spiritual ground of its teeming, exuberant culture.

In America he presented the wisdom of his tradition in contemporary idioms and examples. He often taught in the language of psychology rather than the language of religion. He worked with Western cultural forms to train his students, launching projects in film, theater, and psychotherapy. He used photography and other art forms to express the experience of the awakened state of mind. His teachings were perfectly suited to the time and place, and the scale of his activities expanded rapidly.

Andy first met Trungpa Rinpoche in 1971 in San Francisco, where he was practicing Zen under Shunryu Suzuki Roshi. The next summer, after Suzuki Roshi's death, he moved to Colorado to continue his training with Trungpa Rinpoche. He studied Buddhism, practiced meditation, and participated in Trungpa Rinpoche's theater group, eventually becoming its director. During this period, Trungpa Rinpoche presented a slide show to the theater group that vividly conveyed the unfabricated way he saw the world. The fresh images conveyed space, form, and energy. They were completely free from story line and seemed to show the essence of things rather than concepts about them. The images transmitted wakefulness. Inspired by these photographs, Andy went out and shot a few rolls of slides, trying to emulate his teacher. The experiment wasn't a complete failure, but he had no idea how to take it further.

At about the same time, Michael was working as a professional photographer in Toronto. He had studied photography in college and had achieved some success as a commercial, fashion, and portrait photographer. In 1976 he began to meditate, and he soon began to notice subtle changes in the patterns of his perceptions. Every once in a while, a fresh, almost unrecognizable perception would occur out of nowhere, and he would try to photograph it. The more he meditated, the more these perceptions arose. He began to see a connection: the more space there was in his mind, the more the world presented itself nakedly to him.

In 1979 he saw some of Trungpa Rinpoche's slides in a course titled "Tantric Iconography." What he saw stopped him in his tracks. He had never encountered images that were so fresh, spacious, and free from conventional rules of composition or subject matter. Because he had trained in traditional composition and standard photographic concepts, and incorporated them into his work for years, the images shook him deeply.

His reaction was conflicted. On the one hand, he was attracted to the fresh, awake, and unpredictable nature of Trungpa Rinpoche's work. On the other hand, his professional sensibilities were offended by the absence of familiar photographic principles and the lack of technical excellence. This split caused an immediate creative crisis as he realized that his orthodox photography was nothing in comparison. He had a premonition that his conventional photographic career was about to come to an end.

During the following months Michael studied and contemplated Trungpa Rinpoche's Dharma Art teachings, an approach to the creative process based on Buddhist principles and the practice of meditation. These teachings presented the view that art could express the actual moment-to-moment experiences of life, free from any artistic agenda designed to appeal to a particular audience. In this approach, real creativity is based on openness, genuineness, and confidence.

Michael decided to try to learn to shoot like Trungpa Rinpoche, but he knew that he couldn't just copy his style. He had an intuition that he should work with the same approach he learned in meditation: simplify things to the minimum, try to rest the mind rather than seek entertainment, be curious about seemingly ordinary experience.

For months he restricted himself to his little backyard, going out again and again, trying to see. The backyard had a fence, a garage, a wall of the house, dandelions, and a small garden. It offered little novelty or entertainment. He stayed in that environment and looked and looked. He would go out for an hour or two each day after work, exploring his perceptions and taking pictures. Gradually ideas about what he should be seeing and shooting wore out, and he started connecting directly with the visual world. Fresh perceptions started to come more regularly. He shot very simple things: grass by the sidewalk; snow, melting snow, and sidewalk; the garage door; sunlight on the grass. The perceptions were simple but fresh.

After that he expanded his investigations to the alleyway behind the house. His two young children walked up and down the alleyway with him after school, entertaining themselves while he looked and shot. He shot hundreds of rolls of film in that period. One day his three-year-old son came running up to him and said, "I found something you'll like." At the end of the alleyway, lying on the street, was a big maple leaf coated with gasoline and shimmering with the colors of the rainbow. His son had no notion

about gasoline on the leaf's being bad; he just saw the rainbow. That showed Michael how fresh and uncontrived seeing could be.

Before his time in the backyard and alleyway, the only thing Michael really enjoyed photographing was dramatic scenery, mostly sunsets. During his retraining period, there wasn't much drama to be found in the dirt, old cars, fences, and garages. Instead, he discovered the joy of seeing and shooting form and space, the same qualities that spoke to him in Trungpa Rinpoche's images. He spent the next three years synthesizing these experiences and shooting a fresh body of work. Showing this work to friends led to an invitation to begin teaching contemplative photography.

Michael started to present this new way of working by dividing it into three stages of practice. He developed exercises to help students connect with the experience of clear seeing and devised photographic assignments to use in his workshops. Over the next twenty-five years, he has refined and evolved these methods into a coherent system of training that draws upon Buddhist teachings on perception and creativity; the insights of great photographic masters such as Stieglitz, Weston, and Cartier-Bresson; and his own experience. This is the practice that we call contemplative photography.

Chögyam Trungpa, Bhutan, 1968.

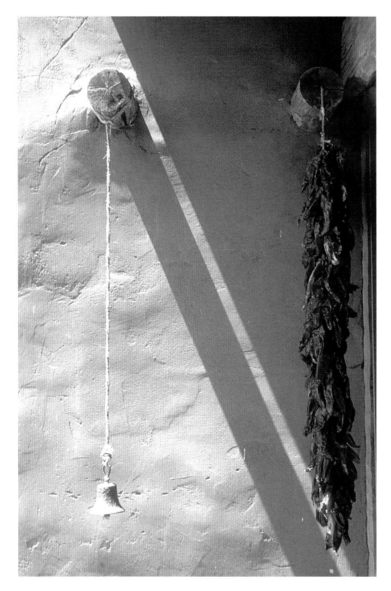

Chögyam Trungpa, Bhutan, 1968.

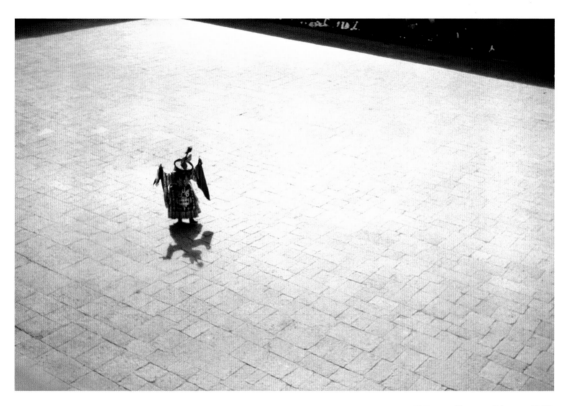

Chögyam Trungpa, Bhutan, 1968.

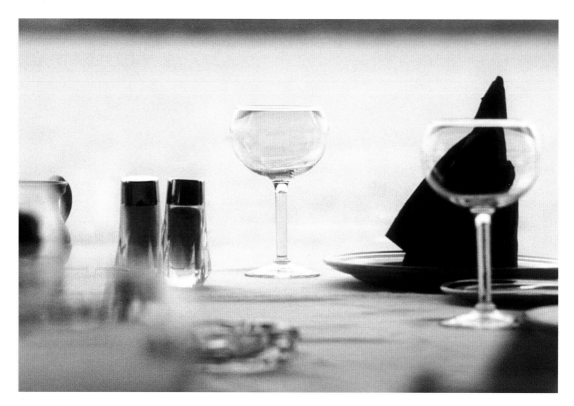

Chögyam Trungpa, Cape Breton, 1979.

Chögyam Trungpa, Cape Breton, 1979.

Chögyam Trungpa, Mexico, 1973.

Chögyam Trungpa, location and date unknown.

Acknowledgments

We have benefited greatly from the pioneering work of many wonderful artists: the fresh, uncontrived photographs of Alfred Stieglitz, Edward Weston, Tina Modotti, André Kertész, Paul Strand, Henri Cartier-Bresson, Robert Adams, and others; the paintings of brilliant, direct perceptions by Claude Monet and other impressionists; the haiku of Matsuo Bashō, Yosa Buson, and Kobayashi Issa, which show that clear seeing can be vividly expressed in words—we are grateful to all of these masters for enriching our lives and showing that the essence of art is seeing and expressing *things as they are*.

Yet, had it not been for the kindness of Chögyam Trungpa Rinpoche, we would have nothing at all worth saying. He introduced us to contemplative photography, taught us to meditate, showed us the art of everyday life, opened our doors of perception, pointed out the sources of natural creativity, and generally made life worth living. We are continually grateful to this extraordinary teacher.

The methods and exercises that form the basis of this book were originally developed by Michael in his early Miksang Contemplative Photography programs. Many people deserve recognition for helping with this. Ösel Tendzin, Trungpa Rinpoche's first Western successor, nurtured and guided the development of the contemplative photography practice for several years, while it was in its infancy. Without his support and personal inspiration, it could well have died early on. Also in those early days, Stanley Fefferman introduced Michael to Trungpa Rinpoche's Dharma Art teachings, encouraged him to write a Miksang sourcebook, and helped launch the first programs; John McQuade helped think through the logic and view of the courses, collaborated on a second sourcebook, introduced Bashō's haiku into the training, and was instrumental

in the general development of Miksang; Ken Green made important connections and provided support; and Catherine Pilfrey pointed out the similarities between the painting and writing of the Impressionists and the practice of contemplative photography.

Later on, Julie DuBose became the first person to graduate from Miksang student to fully qualified Miksang teacher. Until she came along, the programs had never been presented outside Toronto and Halifax. More than anyone, she is responsible for taking them to the larger world. Julie also had the inspiration for, and collaborated on developing, the Essential Instructions workshop and helped develop the first teacher-training seminar. Julie is able to present all the Miksang levels and has been traveling to teach programs and working closely with Michael for more than ten years. Her contributions to the development of these teachings, and to this book, have been profound.

Whit and Paula Jones recognized the value of these teachings and generously supported the development of a Miksang Web site and other activities that made it possible to present the workshops around the world. Their kindness and friendship are greatly appreciated.

Khenpo Tsültrim Gyamtso Rinpoche introduced us to profound teachings on perception and repeatedly demonstrated the art of expressing the inexpressible. This clarified our understanding of contemplative photography and showed us new ways of presenting it to others. Dzogchen Ponlop Rinpoche and Scott Wellenbach patiently deepened and expanded our understanding of these principles of perception.

Our friend, first reader, and counselor, Barry Boyce, senior editor of the *Shambhala Sun* and *Buddhadharma*, gave us invaluable insights, advice, and support throughout the long gestation of this project.

Our wonderful editor at Shambhala Publications, Emily Bower, nurtured this project from its inception, guiding us with warmth and skill around pitfalls and obstacles (mostly of our own making) in the writing, editing, and publishing of this book. Also at Shambhala, Peter Turner, the president, advised and encouraged us with insight and kindness, and Ben Gleason carefully tracked the many details that this complex undertaking entailed.

We are grateful to many friends, colleagues, and fellow contemplative photographers who provided us with companionship, support, advice, and great tolerance for our many eccentricities. We are particularly grateful to Jim and Carolyn Gimian, Liza Matthews, Mary Lang, Ari Goldfield, Tim Olmsted, Jay Garfield, Jill Scott, and many others—far too numerous to mention.

Finally, we are grateful to our families: Wendy Karr, Alden Karr, Missy Chimovitz, and Doug Karr, and Julie DuBose, Sarah Wood, Rob White, Ben Wood, and Sarah Jane

Richards, who supplied us with endless amounts of inspiration, nourishment, and love. May we fully reciprocate their kindness.

 May this book be of benefit to anyone who wishes to see clearly, photograph beautifully, and experience the source of natural creativity!

Choosing a Camera

Because contemplative photography puts the emphasis on working with mind and eye, almost any recent digital camera will be suitable for this practice. You definitely *don't* need the latest and greatest equipment to make good images. In fact, too much concern with gear will distract you from clear seeing and the contemplative aspects of the practice. Having said that, working with a camera that is easy to use, well made, and manually adjustable will be more pleasing and rewarding than working with one that is poorly designed and frustrating to operate.

We can't recommend specific models or brands because there are hundreds to choose from, and they are continually changing. Instead, we offer some general considerations that can guide you to a good choice. To evaluate particular cameras currently on sale you can consult reviews and recommendations in photography magazines and on the Internet. A good place to begin is the Digital Photography Review Web site at www.dpreview .com. Other sites worth checking are Steve's Digicams at www.steves-digicams.com, the Digital Camera Resource Page at www.dcresource.com, and Camera Labs at www .cameralabs.com.

You can buy a used camera to save money, but exercise as much caution as you would buying any other used portable electronic equipment, and bear in mind that digital cameras have improved rapidly in the past few years.

Digital SLR or Compact Camera

When choosing a camera, the first thing to consider is whether you want a DSLR or a compact. We use both. DSLRs generally offer better image quality, more flexibility,

better low-light performance, and more manual controls. Compact cameras are generally smaller, lighter, simpler to operate, and less expensive. Overall, a DSLR will give you more control over the photographic process; a compact is more likely to be with you in daily life when you are stopped by a flash of perception.

Sensors

For years, camera manufacturers marketed ever-larger megapixel counts to sell their wares. Today it is hard to find a camera with less than an eight-megapixel sensor. For most purposes, eight megapixels is more than enough. The key question is not how many pixels a camera has but how good the image quality is, particularly in low light.

Image quality depends less on the number of pixels, than on the size and overall design of the sensor: cramming more pixels onto a tiny sensor will degrade image quality, not improve it. Compact cameras generally have much smaller sensors than DSLRs that have similar pixel counts, making the pixels much smaller and noisier. That is why DSLRs tend to produce cleaner images with more dynamic range than compact cameras.

Lenses

The most important lens considerations are speed (maximum aperture) and focal length(s). Ideally, a lens should be fast enough to use in low light without needing to really boost the ISO. You will probably want a lens with a maximum aperture of f/2.8 or faster. (Note: the maximum aperture of zoom lenses decreases as you increase the focal length, sometimes dramatically.)

Currently, one of the big marketing features for camera manufacturers is zooms with large magnification ratios (up to 20x and more). You definitely don't need a super-zoom to form the equivalent of your perceptions. A lens in the 3x to 5x range is fine. If you have a camera that takes interchangeable lenses, consider using a fixed focal length normal lens as well as, or instead of, a zoom lens with a moderate range of focal lengths.

Some lenses offer optical image stabilization (sometimes called vibration reduction, or antishake), which allows you to make sharper images at slow shutter speeds, particularly at longer focal lengths. This is a useful feature.

Usability

An unresponsive camera with long shutter lag and/or slow focusing will be really dispiriting. This is a very important consideration. Most DSLRs and better-quality compact

cameras are quite responsive. Another important consideration is that the camera should feel good in your hands. A camera that is too small and light will be hard to keep steady. A camera that is too large and heavy will spend too much time on a shelf at home. We prefer cameras with a bit of heft and a reasonable grip, but this is something you need to feel for yourself.

A large, high-quality LCD is really helpful for reviewing images. You will also need the LCD for framing images when using a compact camera with no viewfinder or one that isn't particularly accurate. Lower-quality LCDs wash out in bright sunlight, look grainy in low light, and change color when viewed from different angles. This has a big impact on usability.

The choice and placement of controls varies widely among cameras. It is nice to be able to use real buttons and dials to change settings without going through long, complicated menus, but these are features usually found on more expensive cameras. Whatever controls a camera has, their size and placement is definitely important and something you need to look into.

Good battery life is another thing to look for. (Manufacturers rate battery life according to standards produced by the Japanese Camera & Imaging Products Association (CIPA), but it is often hard to find these ratings.) A decent camera should get more than a couple hundred shots per battery charge in normal usage.

An advanced feature that many serious photographers look for is the ability to shoot RAW images as well as JPEGs. RAW files contain the original image data from the camera's sensor, unlike JPEG files, which are processed and compressed within the camera. RAW files preserve the maximum amount of image detail and provide greater flexibility and latitude for adjusting images on a computer.

Test Drive

You can learn a lot about cameras from reviews and specifications, but a visit to a store that sells a wide range of cameras is really helpful. Better yet, if you have a friend who owns a model you are considering, see if you can borrow it for an hour of shooting. That should tell you how good a fit that camera is with your personal preferences.

Working with Images

The practice of contemplative photography does not end when you finish shooting: editing and adjusting your images is an important part of the process. The first thing you should do after shooting is spend some time with each of your images. Try to see which ones work and which do not. Don't be in a hurry to delete the ones that you don't like, but try to learn from them. See if you can remember what was going on in your state of mind when you took the shot. Did you get excited and lose track of the perception? Did you overlook an important setting? Did you try to "improve" your perception in some way? You don't have to second-guess yourself, just see how the results were affected by what you were doing. Editing images is a way of giving yourself feedback. It is also a way of refining your understanding of perception and developing your photographic sensibilities.

Reviewing images will sometimes bring up hidden emotional patterns: you might react more to the way you feel about *yourself* at the moment than to your images. Sometimes you might look at what you have shot and be attached to all of them. Sometimes you might be repelled by all of them. When either of these reactions happens, try to recognize what is going on and let go of the emotionality. If you can't do that, put the review aside until later and take a fresh start.

When you look at a photograph, you can ask yourself these questions:

- Was the shot based on a real flash of perception or an idea about the subject matter?
- Did you discern the qualities and the details of the perception before raising the camera, or did you excitedly shoot from the hip?

- Did you accurately form the equivalent of your perception, or did you try to dress it up with compositional techniques?

A well-executed image will be as clear and alive as the original perception. On the other hand, you will find yourself needing to explain why the near misses are in fact good shots. It's fairly easy to tell when an image succeeds and when it doesn't, but often you won't want to let go of the near misses. Don't worry. After some time, those explanations will wear thin and you will be able to get rid of the shots that don't really make it. You don't need to rush this process, but remember, the delete key is your friend. It should remind you that there is a big difference between real experiences and imitations. It should also remind you that the possibilities of perception are limitless.

Adjusting Images on the Computer

After you transfer your photographs to a computer, there are a few simple corrections you should make that will significantly improve their quality. We will describe the way to make these adjustments with the Levels tool in Photoshop, but other image-editing software will have similar tools.

Most digital images benefit from adjustments to their tonal range, contrast, and brightness. The Levels tool provides an effective method for doing this. The Levels tool gives a graphic representation of the distribution of brightness levels in an image in the form of an *image histogram*. This is a bar graph that shows how many pixels there are at each level of brightness. The extreme right side of the histogram shows how many pixels are completely white. The extreme left side of the histogram shows how many pixels are completely black.

Graphs of images with lots of highlight detail (technically called high-key images) will have one or more peaks on the right side of the histogram. Graphs of images with lots of shadow detail (low-key images), will have one or more peaks on the left side of the histogram. Peaks in the middle of the graph show that images have lots of midtone detail.

Each image has a unique histogram, and there are no ideal shapes to aim for. What you don't want is to have pixels piling up at the edges of the histogram, because these represent clipped shadows (areas with no detail that are completely black) and blown-out highlights (areas with no detail that are completely white). (We are describing histograms in image-editing software, but many cameras also have histogram tools, which can be useful for determining correct exposure.)

Adjusting the Tonal Range

When you look at a series of histograms, the first thing you should notice is that the pixels are rarely distributed across the entire range of brightness levels. Whether the image is high-key, low-key, or average, there will probably be parts of the graph with no pixels at all, on either the right side, the left side, or both sides, because digital cameras often use only part of the available tonal range. This can produce low-contrast images that look flat. You can improve these images with the Levels tool by stretching the tonal range over the full range of possible values. You do this by adjusting the levels of the *white point* (the brightest point in the image) and the *black point* (the darkest point in the image).

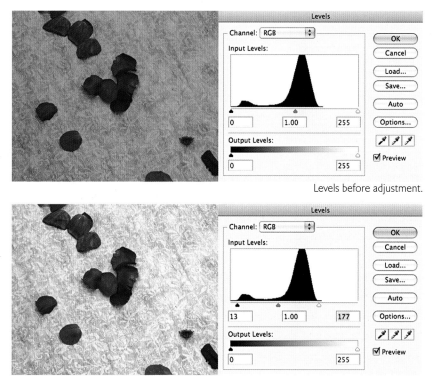

Levels before adjustment.

Levels after adjustment.

Begin by setting the white point with the white point Input Level slider, the small triangle under the *right* side of the histogram. As you move this slider to the left, the image will brighten. Generally you will want to set the white point just to the right of the first peak on the right side of the histogram. If you move it too far, the highlights in the image will blow out. (Sometimes, you won't need to change the white point at all.)

Next, set the black point with the black point Input Level slider, the small triangle under the *left* side of the histogram. As you move this slider to the right, the image will darken. Generally, you will want to set the black point just to the left of the first peak on the left side of the histogram. If you move it too far, you will lose detail in the shadows in the image. (Sometimes you won't need to change the black point at all.) Stretching the tonal range in this way will increase the contrast of the image.

When you are working with images from scenes where the contrast was low to begin with, or the lighting was unusual—images shot in the mist or under very soft light, for example—setting the white point and black point to the first peaks in the histogram will exaggerate the contrast and distort the image. You might need to set the sliders to the brightest and darkest pixels in the image instead of the first peaks to form a good equivalent. This is something you will need to experiment with.

After you have adjusted the tonal range of the image by setting the white and black points, you might also need to adjust the overall brightness. You do this with the middle Input Level slider, which changes the middle range of tones without dramatically altering the highlights and shadows. Moving this slider to the right will darken the image. Moving it to the left will brighten it.

Adjusting the White Balance

We discussed ways to adjust white balance while you are shooting in chapter 15. Despite your best efforts, you might still need to tweak the color balance in some of your images to remove unnatural color casts. You do this on the computer by determining which objects in the image should be neutral colored (white or gray), and then adjusting the color balance accordingly. There are several different tools that can be used to do this. We will again describe the way these adjustments are made with the Photoshop Levels tool.

After you have adjusted the tonal range of an image with the Levels tool, make sure to save the adjustments by clicking OK, which will dismiss the Levels dialog box. If you don't do this but proceed to use the Levels tool to adjust the white balance, your tonal range adjustments will be lost. Alternatively, you can start by making the white balance adjustments and then continue with the tonal range adjustments without losing your work.

Begin by choosing an area in the image that should be a neutral color. There are three Eyedropper tools within the Levels tool that you use for color correcting: one for highlights, one for midtones, and one for shadows. Click on the one that corresponds to the tonal value of the area you wish to neutralize, and then click on that area. This will change the color balance of the whole image. You might need to experiment with the exact point that you click on in the image to get the best adjustment.

Notes

Preface

1. Henri Cartier-Bresson, *The Mind's Eye: Writings on Photography and Photographers*, 1st ed. (New York: Aperture, 1999), 38.

Chapter 1

1. Nathan Lyons, *Photographers on Photography: A Critical Anthology* (Englewood Cliffs, N.J.: Prentice-Hall, 1966), 97.

2. John Szarkowski, *Looking at Photographs: 100 Pictures from the Collection of the Museum of Modern Art* (New York: Museum of Modern Art, 1973), 194.

3. Edward Weston and Peter C. Bunnell, *Edward Weston on Photography* (Salt Lake City: P. Smith Books, 1983), 144.

4. Robert Adams, *Beauty in Photography: Essays in Defense of Traditional Values*, 2nd ed. (New York: Aperture, 1996), 30.

5. Cartier-Bresson, *Mind's Eye*, 16.

6. Quoted in Yvonne Baby and Elizabeth Carmichael, trans., "Henri Cartier-Bresson: On the Art of Photography," *Harper's Magazine* (November 1961): 74.

7. Edward Weston, *Daybooks* (Rochester, N.Y.: George Eastman House, 1961), 221.

8. Paul Strand, Catherine Duncan, Ute Eskildsen, and Aperture Foundation, *Paul Strand: The World on My Doorstep; an Intimate Portrait* (New York: Aperture, 1994).

Chapter 2

1. Beaumont Newhall, *Focus: Memoirs of a Life in Photography,* 1st ed. (Boston: Little, Brown, 1993), 122.
2. *Los Angeles Times,* August 13, 1978.

Chapter 13

1. Focal length is the distance between the optical center of a lens and the camera's sensor or film when the lens is focused on a subject at infinity. Focal length does not actually describe the physical length of a lens. The complex designs of camera lenses allow their physical lengths to be shorter than their focal lengths.
2. The aperture is the size of the opening in the lens. It is controlled by an adjustable diaphragm made up of overlapping blades.
3. A normal lens has a focal length that is roughly equal to the diagonal measurement of the camera's sensor or film. For most compact cameras with small sensors, that focal length is between 5 and 9 mm. For consumer-level DSLRs, it is between 27 and 35 mm. For full-frame DSLRs and 35 mm film cameras, it is between 45 and 55 mm.
4. F-stops on digital cameras are usually divided more finely than steps of one full stop. Steps of one-third stop are common. Half-stop steps are sometimes used.
5. An f-stop is equal to the focal length divided by the diameter of the lens opening.

Chapter 15

1. Shutter speed settings determine how long the camera's sensor is exposed, or responsive, to light. Some cameras have mechanical shutters that open and close to let light shine on the sensor for the determined amount of time, while other cameras have electronic shutters that switch the sensor on and off for the determined amount of time. Some DSLRs use shutters that combine electronic and mechanical systems for controlling the length of the exposure.
2. Shutter speeds on digital cameras are usually divided more finely than full steps. The increments are chosen to match the increments in f-stops.

Epilogue

1. *Rinpoche* is a Tibetan honorific title for realized Buddhist teachers that means "precious one."
2. The story of this ten-month adventure is recounted by Chögyam Trungpa and Esmé Cramer Roberts in *Born in Tibet,* 3rd ed. (Boston: Shambhala Publications, 1985).
3. Chögyam Trungpa, *First Thought, Best Thought: 108 Poems,* 1st ed. (Boulder, Colo.: Shambhala Publications, 1983), xix.

Contemplative Photography Workshops and Web Site

The Miksang Contemplative Photography workshops led by Michael Wood, Julie Du-Bose, and other instructors educated by them offer excellent opportunities to train in the practices presented in this book. Miksang Workshops also offer more advanced training, which guides students through more and more subtle visual investigations that extend their capacity to see and express their perceptions.

Visit www.miksang.com for more information.

Further Resources

Please visit www.seeingfresh.com to see additional examples of images for the assignments, as well as opportunities to submit your own assignment photographs, ask questions of the authors, and find news of the world of contemplative photography.

RECOMMENDED READING

Cartier-Bresson, Henri, *The Mind's Eye: Writings on Photography and Photographers.* 1st ed. New York: Aperture, 1999.

Trungpa, Chögyam. *True Perception: The Path of Dharma Art*. Boston: Shambhala Publications, 2008.

Credits

Photo by Genice Wickum on page 83 reprinted courtesy of the photographer.

Photos by Sarah Jane Richards on pages 102 and 169 reprinted courtesy of the photographer.

Photo by Nina Maria Mudita on page 100 reprinted courtesy of the photographer.

Photos by Todd Roseman on pages 105 and 119 reprinted courtesy of the photographer.

Photo by Sarah Wood on page 135 reprinted courtesy of the photographer.

Photo by Paula Jones on page 137 reprinted courtesy of the photographer.

Photo by Anne Launcelott on page 150 reprinted courtesy of the photographer.

Photo by Helen A. Vink on page 155 reprinted courtesy of the photographer.

Photo by Benjamin Wood on page 191 reprinted courtesy of the photographer.

Photographs by Chögyam Trungpa on pages 197–203 are copyright Diana J. Mukpo and used by permission. From the collection of the Shambhala Archives.

Adobe product screenshots reprinted with permission from Adobe Systems Incorporated.